A
Rich & Rare Land

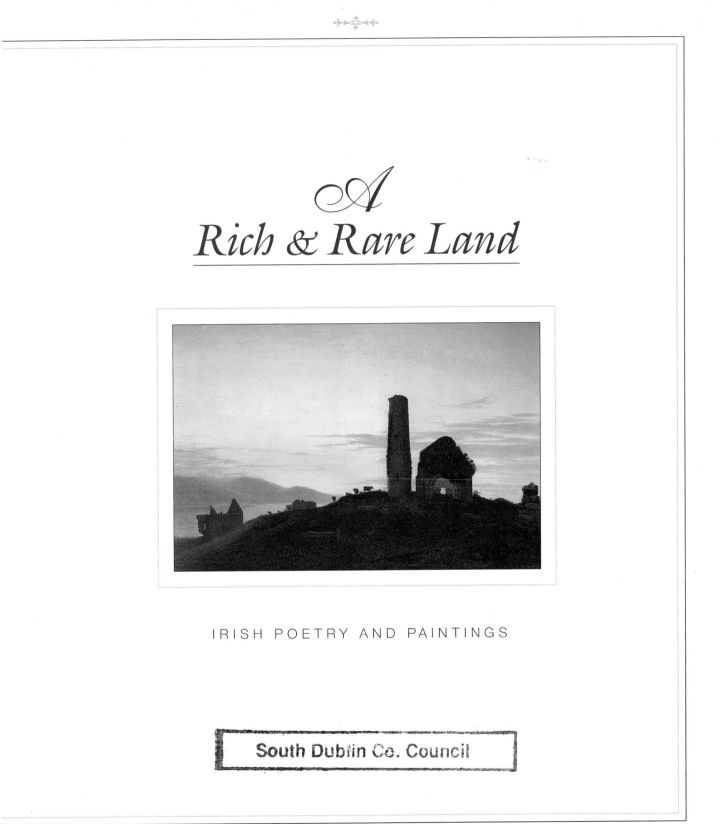

IRISH POETRY AND PAINTINGS

DEDICATION *for Helen*

Credits

Introduction Joseph McMinn
Editor Fleur Robertson
Designer Jill Coote
Production Ruth Arthur, Sally Connolly,
 Neil Randles, Jonathan Tickner
Director of Production Gerald Hughes

Previous page:
 Ruins on Holy Island, Lough Derg, Co. Clare
 Bartholomew C. Watkins
Facing page:
 In the Mournes
 John Luke

Published in Ireland by
Gill & Macmillan Ltd, Goldenbridge, Dublin 8
with associated companies throughout the world

CLB 4267

This selection and Introduction
© 1994 CLB Publishing, Godalming, Surrey, England
ISBN 0 7171 2234 4

Printed and bound in Singapore

\mathscr{A} Rich & Rare Land

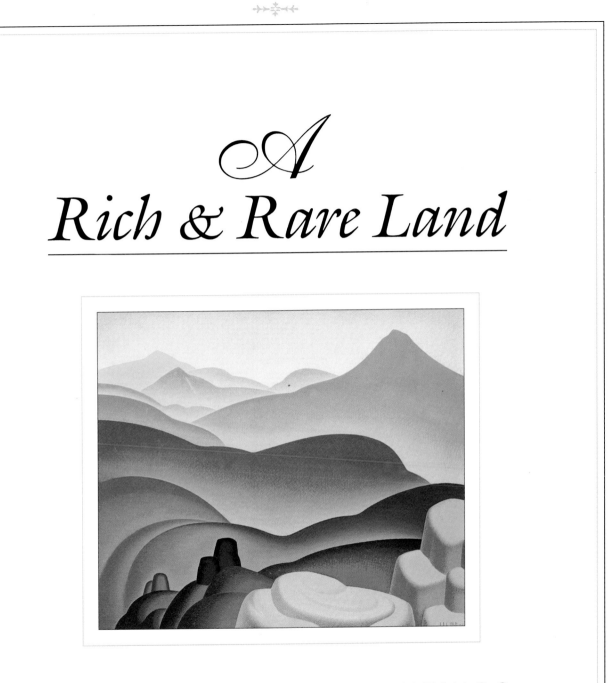

IRISH POETRY AND PAINTINGS

GILL & MACMILLAN

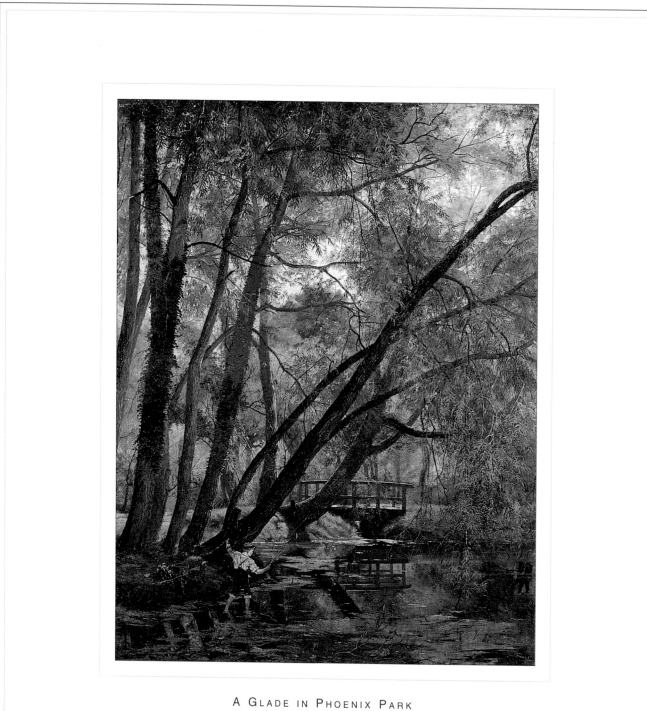

A GLADE IN PHOENIX PARK

Walter Osborne

1859-1903

Contents

Introduction

THE practice of poetry in Ireland is both ancient and enduring, a craft of language which dates back to the sixth century, to early Christian Ireland, making it the oldest vernacular literature in Western Europe. It was born out of the solitary, contemplative lives of the hermits and monks who established centres of learning and piety throughout the island. The first poems they wrote were a form of diversion, a relaxation from their labours as copyists of sacred texts, often no more than a few rhymes penned in the margins of illuminated manuscripts. Several of these short verses survive and give us a glimpse of those religious dreamers at work, suddenly distracted by the beauty and mystery of the landscape around them:

> The cuckoo sings clear in a lovely voice
> In his grey cloak from a bushy fort.
> I swear it now, but God is good!
> It is lovely writing out in the wood.

From these first poetic utterances, Irish verse has retained a strong association with spirituality and Nature. Down through the ages, especially in medieval times, the poet remained an important, respected and feared member of society, someone who preserved tradition, entertained and instructed his listeners and, perhaps most importantly, celebrated the wonders of the imagination.

For over a thousand years the poetry of the island was in the Gaelic language, an integral part of a way of life that began to dissolve in the early eighteenth century. The rise of English, and a new poetical language, did not mean the death of Irish, however, and the most remarkable feature of the tradition is how that past has survived and, in turn, enriched modern Irish verse. Nineteenth- and twentieth-century Irish poets have recovered and reclaimed a rich inheritance of story, song and mythology, translating it into imaginative forms which acknowledge the inspiration of the past, while addressing a new Ireland. One of Ireland's leading contemporary poets, Brendan Kennelly, believes that certain characteristics of Irish poetry have remained constant through all these

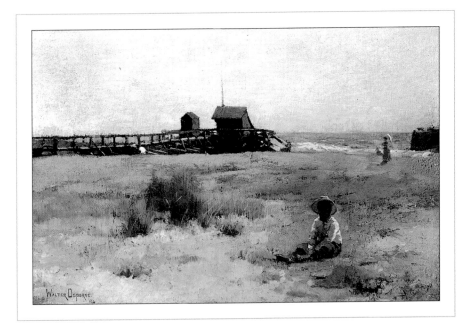

BOY ON A BEACH
Walter Osborne
1859-1903

evolutionary changes, above all that of 'a hard, simple, virile, rhetorical clarity'. This quality may well come from the poetry's origins in religious passion, the bottom layer of a modern art which continues to turn back for guidance.

This selection of modern Irish verse represents many of the distinctive features of such a transition from the past into the present, a rich gathering from the poetic threshold. W. B. Yeats, Ireland's greatest modern poet, speaking at the turn of the century, remarked that writers of his time had much to learn from the cultural past, without necessarily romanticising it, and quoted a proverb from folklore to illustrate his point:

> A tune is more lasting than the song of the birds,
> A word is more lasting than the riches of the world.

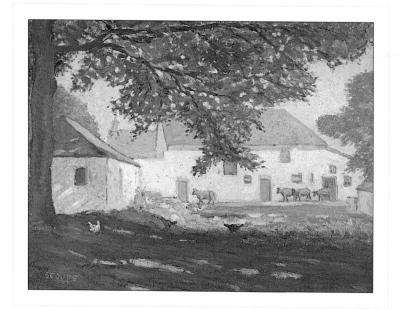

AFTER MILKING TIME
Seamus Stoupe
1872-1949

Yeats knew that such admiration could all too easily become mechanical nostalgia, but that the poet was always part of a tradition, a knowledge that should inspire, but never limit, the imagination, constantly renewing old themes, setting them to new forms of rhythmical expression, working new images into inherited patterns.

Painters and poets have responded to the beauty and the wonder of the Irish landscape, its actuality as well as its spirituality. More than any other subject, perhaps, the landscape has inspired the imagination of these artists, presenting an image of change and continuity, a medium for the expression of the deepest, most personal emotion, and an enviable example of creative order. The poetry ranges across some famous, some previously unsung, landscapes: Yeats' Sligo, Kavanagh's Monaghan, Synge's Wicklow and Hewitt's Glens of Antrim. As a visual counterpoint to the literary

evocation of such places, we have here the pictorial achievements of many Irish artists contemplating the same scenes, such as the violently coloured work of Jack B. Yeats, fascinated as much by the city of Dublin as by the lonely stretches of Connemara, and the quieter, idealised representation of the West of Ireland by the likes of Charles Lamb. The poetry and the painting exhibit a variety of styles – realistic, romantic, symbolic and lyrical – each one appropriate to a passing mood or a passionate conviction.

Landscapes inspire loyalties, sometimes national, as with Patrick Pearse and Thomas Davis, more often local, as with John Montague. Local pride (not always uncritical) is a notable presence here, an especially strong impulse when place is humanised by memory of people whose character seems moulded by the place. This can be seen in the vivid portraits depicted in *Like Dolmens Round My Childhood, the Old People* by John Montague, *The Traveller* by Oliver Goldsmith, and *A Refusal to Mourn* by Derek Mahon, poems which cannot imagine places without their people. This kind of poetic portraiture is an expression, perhaps a revelation, of what Time preserves and destroys, suggesting, as in O'Carolan's *Mabel Kelly*, a sense of beauty's triumph, or in Heaney's *Blackberry-Picking*, a feeling of sensual despair.

One of the oldest and greatest functions of poetry, the celebration of love, is well-represented here in a variety of lyrical forms and tones. Swift's teasing tribute, *Stella's Birthday*, is all the more tender because of its frank intimacy, while Yeats' romantic reveries sound a sustained tragic note. Traditional song and ballad are sometimes used to enhance this kind of verse, as in Thomas Moore's classic *Melodies*, or the coquettish *I Know Where I'm Going*, showing the inspirational bond between poetry and music.

The modern Irish poets are often spoiled for choice when it comes to searching for models of inspiration. A great tradition lies behind them, in two languages, ready to offer a rich hoard of image and song, although each poet must also find an original voice which adds to that tradition. Some of our finest poets, such as Derek Mahon, in poems like *Everything Is Going To Be All Right*, seem to have achieved this delicate balance between acceptance and independence. His work seems a fitting emblem of a body of poetry which has kept faith with its contemplative roots, and which persists in being stubbornly inventive.

Joseph McMinn, Belfast 1994

An Irish Love Song

O, you plant the pain in my heart with your wistful eyes,
 Girl of my choice, Maureen!
Will you drive me mad for the kisses your shy sweet mouth denies,
 Maureen!

Like a walking ghost I am, and no words to woo,
 White rose of the West, Maureen;
For it's pale you are, and the fear that's on you is over me too,
 Maureen!

Sure it's our complaint that's on us, asthore, this day,
 Bride of my dreams, Maureen;
The smart of the bee that stung us, his honey must cure, they say,
 Maureen!

I'll coax the light to your eyes, and the rose to your face,
 Mavourneen, my own Maureen,
When I feel the warmth of your breast, and your nest is my arms' embrace,
 Maureen!

O where was the King o' the World that day – only me,
 My one true love, Maureen,
And you the Queen with me there, and your throne in my heart, machree,
 Maureen!

JOHN TODHUNTER
1839-1916

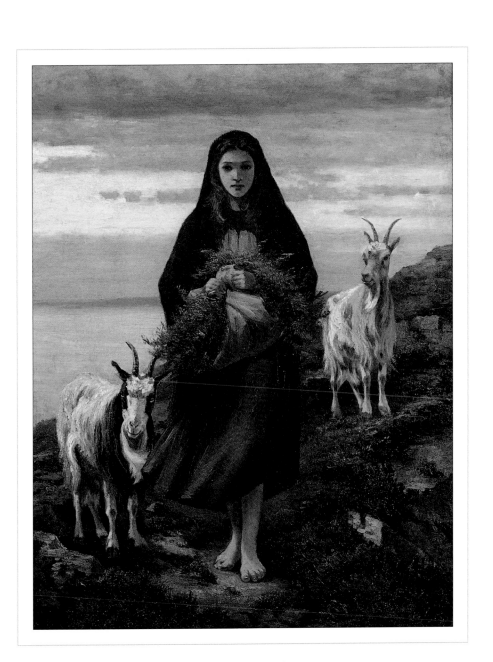

A CONNEMARA GIRL

Augustus Burke

c1838-1891

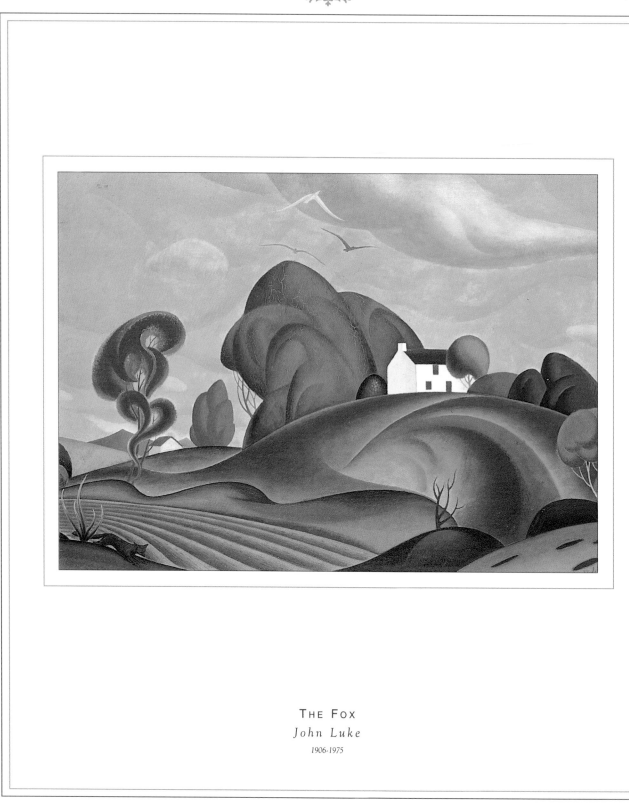

THE FOX

John Luke

1906-1975

Blackberry-Picking

for Philip Hobsbaum

Late August, given heavy rain and sun
For a full week, the blackberries would ripen.
At first, just one, a glossy purple clot
Among others, red, green, hard as a knot.
You ate that first one and its flesh was sweet
Like thickened wine: summer's blood was in it
Leaving stains upon the tongue and lust for
Picking. Then red ones inked up and that hunger
Sent us out with milk-cans, pea-tins, jam-pots
Where briars scratched and wet grass bleached our boots.
Round hayfields, cornfields and potato drills
We trekked and picked until the cans were full,
Until the tinkling bottom had been covered
With green ones, and on top big dark blobs burned
Like a plate of eyes. Our hands were peppered
With thorn pricks, our palms sticky as Bluebeard's.

We hoarded the fresh berries in the byre.
But when the bath was filled we found a fur,
A rat-grey fungus, glutting on our cache.
The juice was stinking too. Once off the bush
The fruit fermented, the sweet flesh would turn sour.
I always felt like crying. It wasn't fair
That all the lovely canfuls smelt of rot.
Each year I hoped they'd keep, knew they would not.

SEAMUS HEANEY
1939-

A Noble Boy

The woman was old and feeble and grey,
And bent with the chill of the winter's day;
The street was wet with the recent snow,
And the woman's feet were weary and slow.
She stood at the crossing and waited long,
Alone, uncared for, amid the throng.
Down the street, with laughter and shout,
Glad in the freedom of 'school let out',
Came the boys, like a flock of sheep;
Hailing the snow, piled white and deep.
Past the woman, so old and grey,
Hastened the children on their way,
Nor offered a helping hand to her,
So meek, so timid, afraid to stir.

At last came one of the merry troop –
The gayest boy of all the group;
He paused beside her, and whispered low,
'I'll help you across if you wish to go';
He guided the trembling feet along,
Proud that his own were firm and strong.
Then back again to his friends, he went,
His young heart happy, and well content,
'She is somebody's mother, boys, you know,
Although she is old and poor and slow.
And I hope some fellow will lend a hand
To help my mother – you understand –
If e'er she be poor and old and grey,
When her own dear boy is far away.'

And 'somebody's mother' bowed low her head,
In her home that night, and the prayer she said
Was, 'God be kind to the noble boy,
Who is somebody's son, and pride, and joy.'

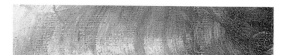

ANONYMOUS

PORTRAIT OF A BOY
Nathanial Hone
1718-1784

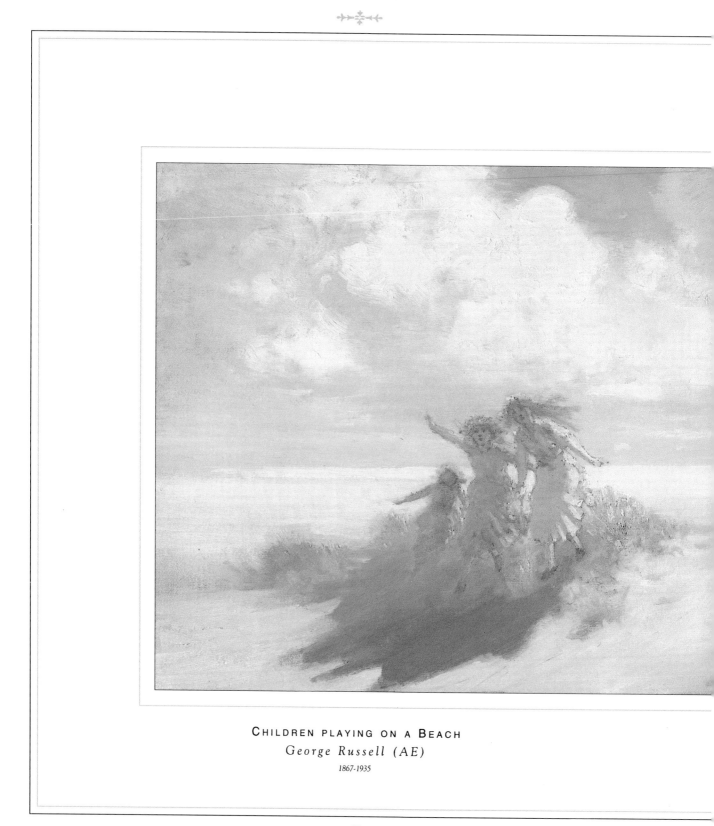

CHILDREN PLAYING ON A BEACH
George Russell (AE)
1867-1935

To a Child
Dancing in the Wind

I

Dance there upon the shore;
What need have you to care
For wind or water's roar?
And tumble out your hair
That the salt drops have wet;
Being young you have not known
The fool's triumph, nor yet
Love lost as soon as won,
Nor the best labourer dead
And all the sheaves to bind.
What need have you to dread
The monstrous crying of wind?

II

Has no one said those daring
Kind eyes should be more learn'd?
Or warned you how despairing
The moths are when they are burned,
I could have warned you, but you are young,
So we speak a different tongue.

O you will take whatever's offered
And dream that all the world's a friend,
Suffer as your mother suffered,
Be as broken in the end.
But I am old and you are young,
And I speak a barbarous tongue.

WILLIAM BUTLER YEATS
1865-1939

The Mother

I do not grudge them: Lord, I do not grudge
My two strong sons that I have seen go out
To break their strength and die, they and a few,
In bloody protest for a glorious thing,
They shall be spoken of among their people,
The generations shall remember them,
And call them blessed;
But I will speak their names to my own heart
In the long nights;
The little names that were familiar once
Round my dead hearth.
Lord, thou art hard on mothers:
We suffer in their coming and their going;
And tho' I grudge them not, I weary, weary
Of the long sorrow – And yet I have my joy:
My sons were faithful, and they fought.

PATRICK PEARSE
1879-1916

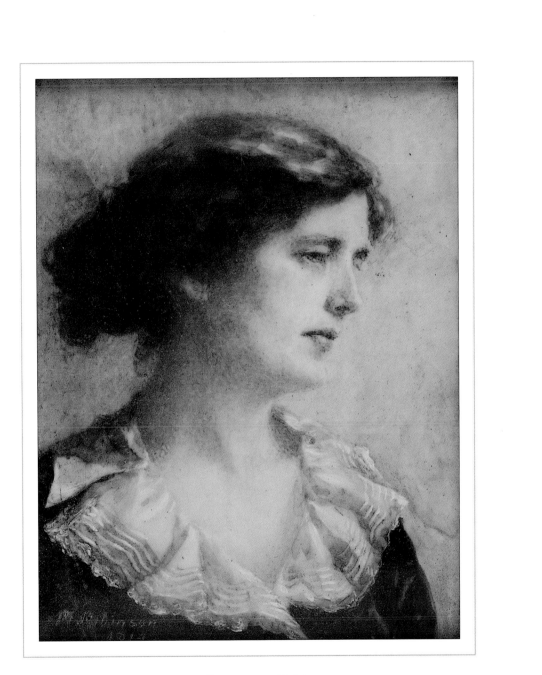

REVERIE, 1914

A. Marjorie Robinson

1858-1924

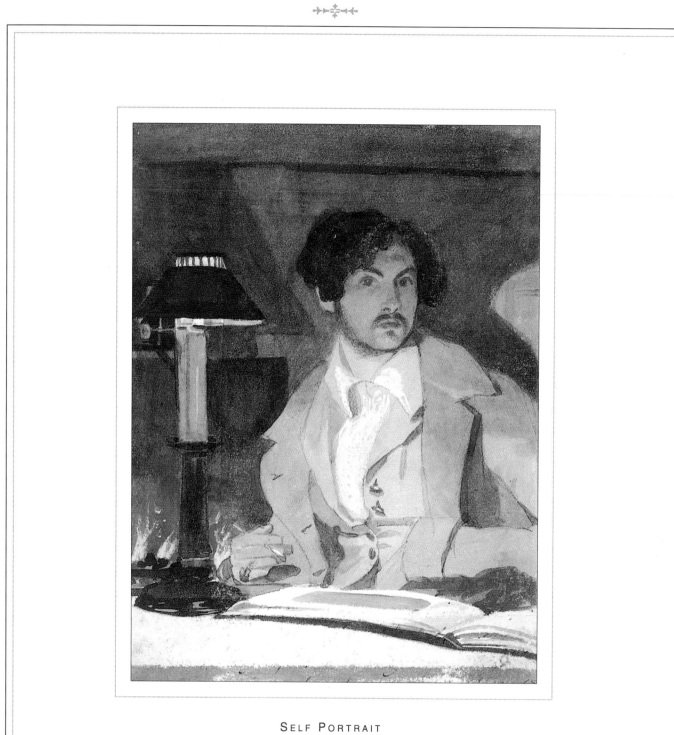

SELF PORTRAIT
Daniel Maclise
1806-1870

O d e

We are the music-makers,
 And we are the dreamers of dreams,
Wandering by lone sea-breakers,
 And sitting by desolate streams; –
World-losers and world-forsakers,
On whom the pale moon gleams:
Yet we are the movers and shakers
 Of the world forever, it seems.

With wonderful deathless ditties
We build up the world's great cities,
 And out of a fabulous story
 We fashion an empire's glory:
One man with a dream, at pleasure,
 Shall go forth and conquer a crown;
And three with a new song's measure
 Can trample an empire down.

We, in the ages lying
 In the buried past of the earth,
Built Nineveh with our sighing,
 And Babel itself with our mirth;
And o'erthrew them with prophesying
 To the old of the new world's worth;
For each age is a dream that is dying,
 Or one that is coming to birth.

ARTHUR O'SHAUGHNESSY
1844-1881

A Nation
Once Again

When boyhood's fire was in my blood,
 I read of ancient freemen,
For Greece and Rome who bravely stood,
 Three Hundred men and Three men.
And then I prayed I yet might see
 Our fetters rent in twain,
And Ireland, long a province, be
 A Nation once again.

And, from that time, through wildest woe,
 That hope has shone, a far light;
Nor could love's brightest summer glow
 Outshine that solemn starlight:
It seemed to watch above my head
 In forum, field and fane;
Its angel voice sang round my bed,
 'A Nation once again.'

It whispered, too, that 'freedom's ark
 And service high and holy,
Would be profaned by feelings dark,
 And passions vain or lowly;
For freedom comes from God's right hand,
 And needs a godly train;
And righteous men must make our land
 A Nation once again.'

So, as I grew from boy to man,
 I bent me to that bidding –
My spirit of each selfish plan
 And cruel passion ridding;
For, thus I hoped some day to aid –
 Oh! can such hope be vain?
When my dear county shall be made
 A Nation once again.

THOMAS DAVIS
1814-1845

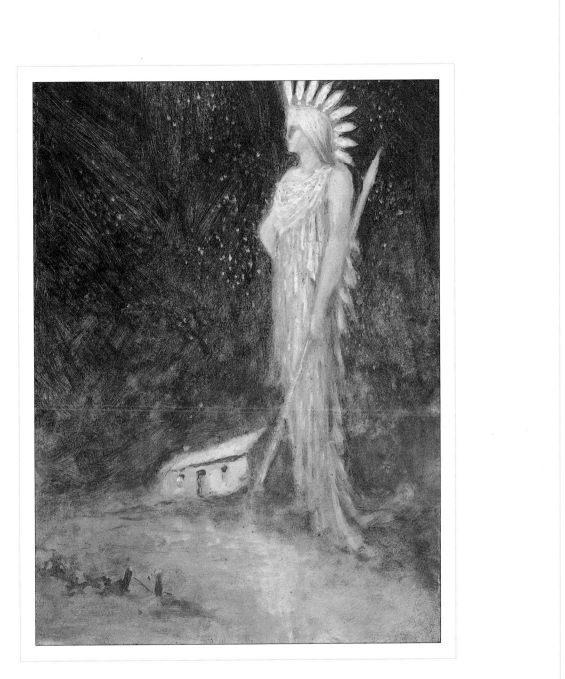

A SPIRIT IN A LANDSCAPE
George Russell (AE)
1867-1935

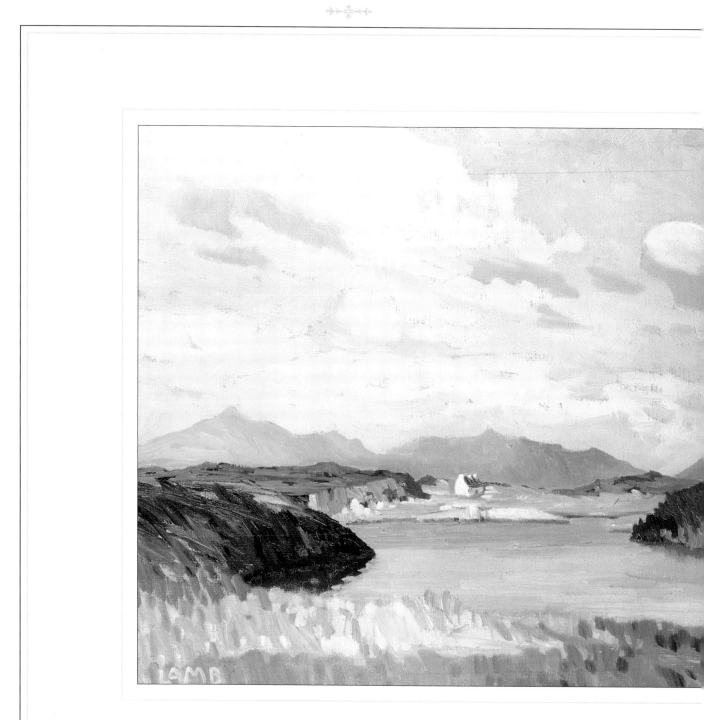

CONNEMARA LANDSCAPE

Charles Vincent Lamb

1893-1964

The Wind that Shakes the Barley

There's music in my heart all day,
I hear it late and early,
It comes from fields are far away,
The wind that shakes the barley.

Above the uplands drenched with dew
The sky hangs soft and pearly,
An emerald world is listening to
The wind that shakes the barley.

Above the bluest mountain crest
The lark is singing rarely,
It rocks the singer into rest,
The wind that shakes the barley.

Oh, still through summers and through springs
It calls me late and early.
Come home, come home, come home, it sings,
The wind that shakes the barley.

KATHARINE TYNAN
1861-1931

Two Songs

1. His Song
Months on, you hold me still;
at dawn, bright-rising, like a hill-
horizon, gentle, kind with rain
and the primroses of April.
I shall never know them again
but still your bright shadow
puts out its shadow, daylight, on
the shadows I lie with now.

2. Her Song
A hundred men imagine
love when I drink wine;
and then I begin to think
of your words and mine.
The mountain is silent now
where the snow lies fresh,
and my love like the sloe-
blossom on a blackthorn bush.

DEREK MAHON
1941-

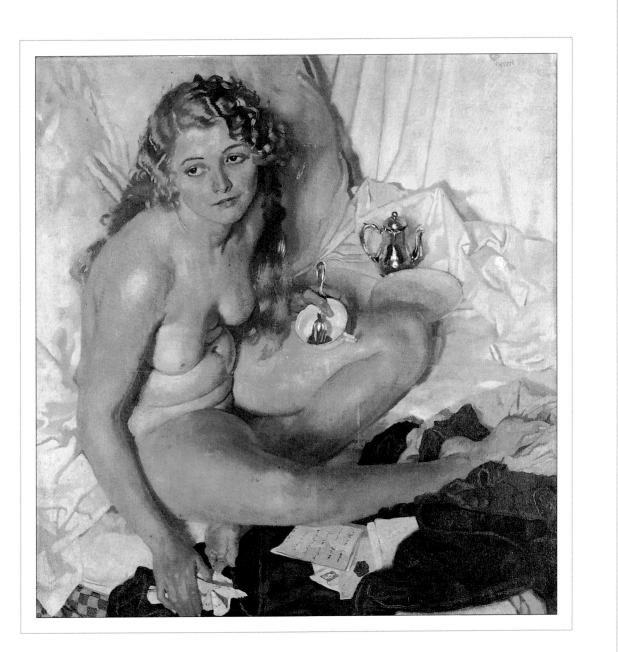

EARLY MORNING

Sir Willliam Orpen

1878-1931

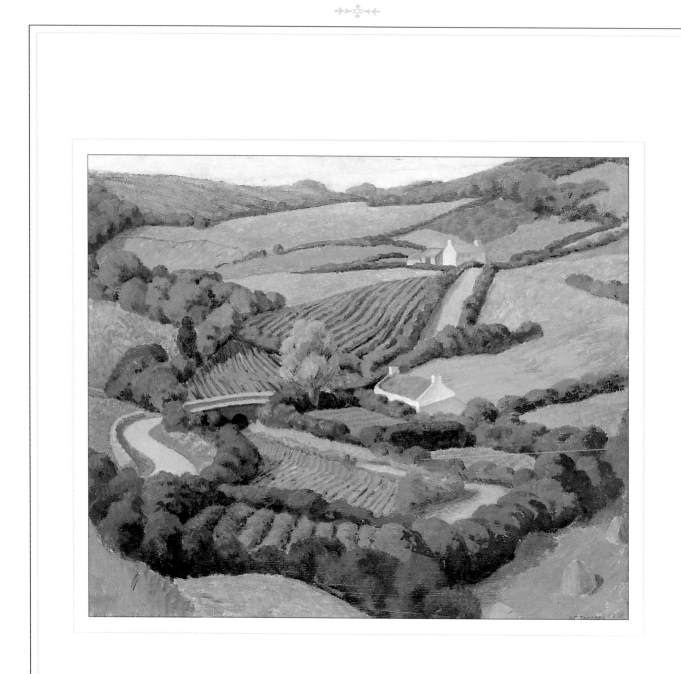

DAN NANCY'S, CUSHENDUN
Romeo Charles Toogood
1902-1966

The Glens

Groined by deep glens and walled along the west
by the bare hilltops and the tufted moors,
this rim of arable that ends in foam
has but to drop a leaf or snap a branch
and my hand twitches with the leaping verse
as hazel twig will wrench the straining wrists
for untapped jet that thrusts beneath the sod.

Not these my people, of a vainer faith
and a more violent lineage. My dead
lie in the steepled hillock of Kilmore
in a fat country rich with bloom and fruit.
My days, the busy days I owe the world,
are bound to paved unerring roads and rooms
heavy with talk of politics and art.
I cannot spare more than a common phrase
of crops and weather when I pace these lanes
and pause at hedge gap spying on their skill,
so many fences stretch between our minds.

I fear their creed as we have always feared
the lifted hand between the mind and truth.
I know their savage history of wrong
and would at moments lend an eager voice,
if voice avail, to set that tally straight.

And yet no other corner in this land
offers in shape and colour all I need
for sight to torch the mind with living light.

JOHN HEWITT
1907-

I am the Mountainy Singer

I am the mountainy singer,
And I would sing of the Christ
Who followed the paths thro' the mountains
To eat at the people's tryst.

He loved the sun-dark people
As the young man loves his bride,
And he moved among their thatches,
And for them he was crucified.

And the people loved him, also,
More than their houses or lands,
For they had known his pity
And felt the touch of his hands.

And they dreamed with him in the mountains,
And they walked with him on the sea,
And they prayed with him in the garden,
And bled with him on the tree.

Not even by longing and dreaming
May they come to him now,
But by the thorns of sorrow
That bruised his kingly brow.

JOHN MILLINGTON SYNGE
1871-1909

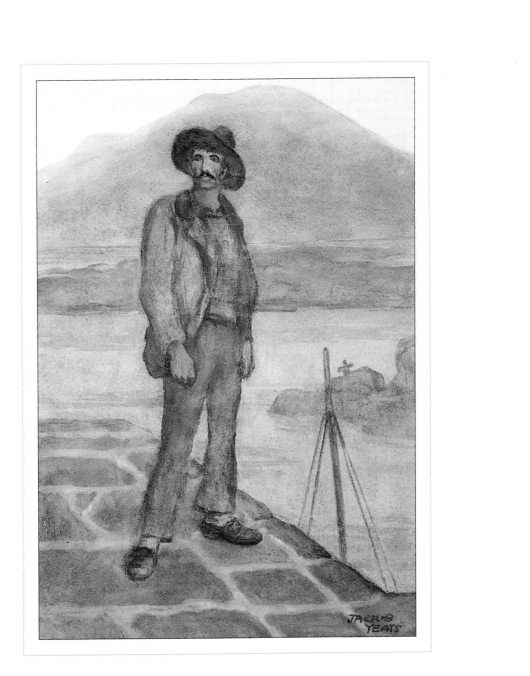

THE MAN FROM ARANMORE
Jack B. Yeats
1871-1957

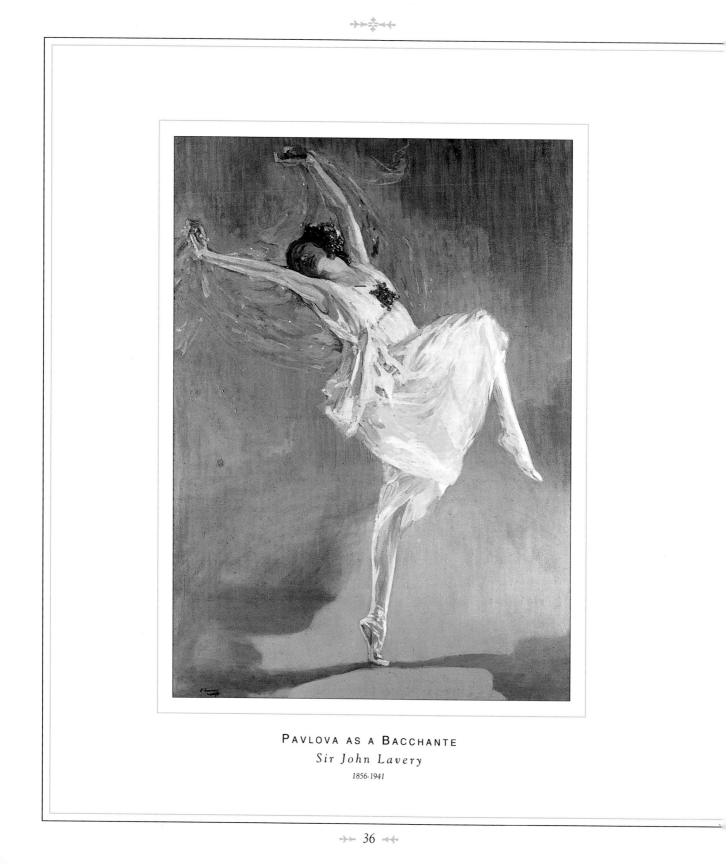

PAVLOVA AS A BACCHANTE

Sir John Lavery

1856-1941

Pursuit
of an Ideal

November is come and I wait for you still
O nimble-footed nymph who slipped me when
I sighted you among some silly men
And charged you with the power of my will.
Headlong I charged to make a passionate kill,
Too easy, far too easy, I cried then,
You were not worth one drop from off my pen.
O flower of the common light, the thrill
Of common things raised up to angelhood
Leaped in your flirt-wild legs, I followed you
Through April May and June into September,
And still you kept your lead till passion's food
Went stale within my satchel. Now I woo
The footprints that you make across November.

PATRICK KAVANAGH
1905-1967

August Weather

Dead heat and windless air,
And silence over all;
Never a leaf astir,
But the ripe apples fall;
Plums are purple-red,
Pears amber and brown;
Thud! in the garden-bed
Ripe apples fall down.

Air like a cider-press
With the bruised apples' scent;
Low whistles express
Some sleepy bird's content;
Still world and windless sky,
A mist of heat o'er all,
Peace like a lullaby,
And the ripe apples fall.

KATHARINE TYNAN
1861-1931

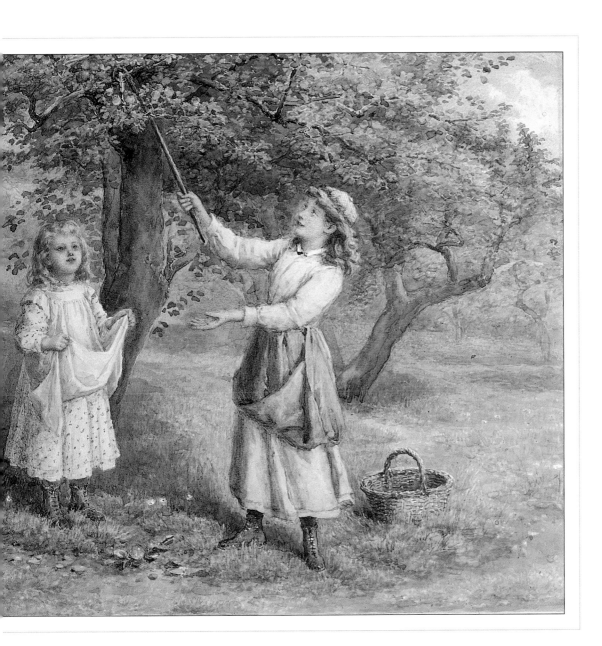

PICKING APPLES

Samuel McCloy

1831-1904

Four Ducks

Four ducks on a pond,
A grass bank beyond,
A blue sky of spring,
White clouds on the wing:
What a little thing
To remember for years –
To remember with tears!

WILLIAM ALLINGHAM
1824-1889

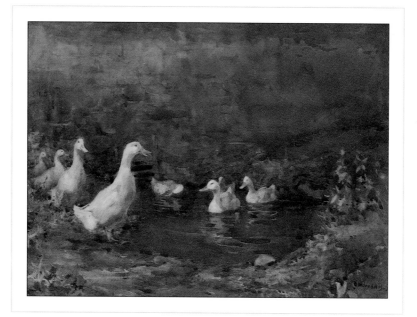

ALERT
Mildred Anne Butler
1858-1941

Train to Dublin

Our half-thought thoughts divide in sifted wisps
Against the basic facts repatterned without pause,
I can no more gather my mind up in my fist
Than the shadow of the smoke of this train upon the grass –
This is the way that animals' lives pass.

The train's rhythm never relents, the telephone posts
Go striding backwards like the legs of time to where
In a Georgian house you turn at the carpet's edge
Turning a sentence while, outside my window here,
The smoke makes broken queries in the air.

The train keeps moving and the rain holds off,
I count the buttons on the seat, I hear a shell
Held hollow to the ear, the mere
Reiteration of integers, the bell
That tolls and tolls, the monotony of fear.

At times we are doctrinaire, at times we are frivolous,
Plastering over the cracks, a gesture making good,
But the strength of us does not come out of us.
It is we, I think, are the idols and it is God
Has set us up as men who are painted wood,

And the trains carry us about. But not consistently so,
For during a tiny portion of our lives we are not in trains,
The idol living for a moment, not muscle-bound
But walking freely through the slanting rain,
Its ankles wet, its grimace relaxed again.

All over the world people are toasting the King,
Red lozenges of light as each one lifts his glass,
But I will not give you any idol or idea, creed or king,
I give you the incidental things which pass
Outward through space exactly as each was.

I give you the disproportion between labour spent
And joy at random; the laughter of the Galway sea
Juggling with spars and bones irresponsibly,
I give you the toy Liffey and the vast gulls,
I give you fuchsia hedges and whitewashed walls.

I give you the smell of Norman stone, the squelch
Of bog beneath your boots, the red bog-grass,
The vivid chequer of the Antrim hills, the trough of dark
Golden water for the cart-horses, the brass
Belt of serene sun upon the lough.

And I give you the faces, not the permanent masks,
But the faces balanced in the toppling wave –
His glint of joy in cunning as the farmer asks
Twenty percent too much, or a girl's, forgetting to be suave,
A tiro choosing stuffs, preferring mauve.

And I give you the sea and yet again the sea's
Tumultuous marble,
With Thor's thunder or taking his ease akimbo,
Lumbering torso, but finger-tips a marvel
Of surgeon's accuracy.

I would like to give you more but I cannot hold
This stuff within my hands and the train goes on;
I know that there are further syntheses to which,
As you have perhaps, people at last attain
And find that they are rich and breathing gold.

<p align="center">LOUIS MacNEICE</p>
<p align="center">*1907-1963*</p>

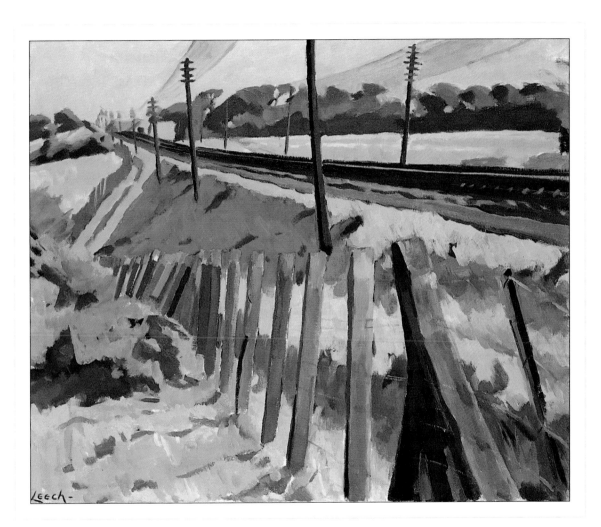

RAILWAY EMBANKMENT

William John Leech

1881-1968

I Know Where
I'm Going

I know where I'm going,
I know who's going with me,
I know who I love,
But the dear knows who I'll marry.

I'll have stockings of silk
Shoes of fine green leather,
Combs to buckle my hair
And a ring for every finger.

Feather beds are soft,
Painted rooms are bonny;
But I'd leave them all
To go with my love Johnny.

Some say he's dark,
I say he's bonny,
He's the flower of them all
My handsome, coaxing Johnny.

I know where I'm going,
I know who's going with me,
I know who I love,
But the dear knows who I'll marry.

ANONYMOUS

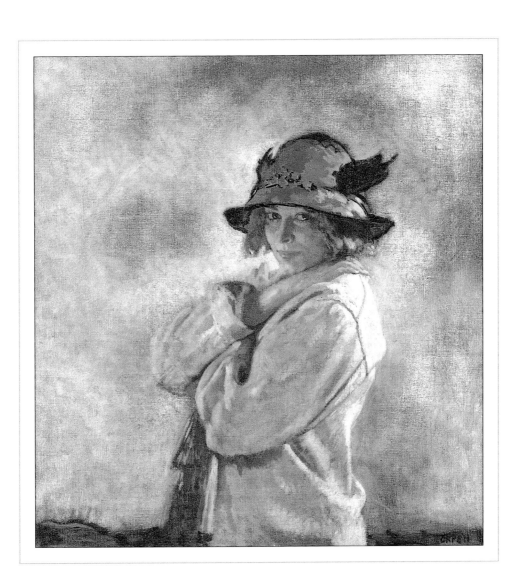

THE BLUE HAT

Sir William Orpen

1878-1931

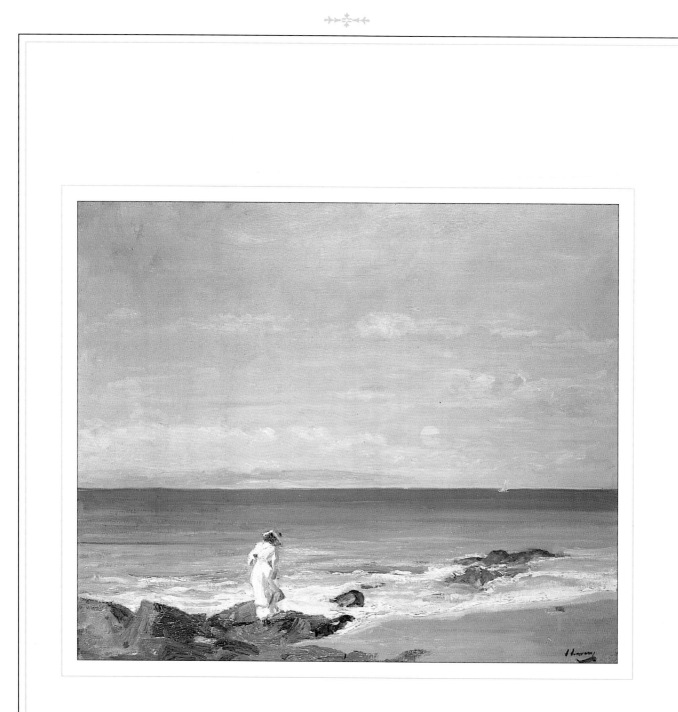

MOONRISE

Sir John Lavery

1856-1941

The Little Waves
of Breffny

The grand road from the mountain goes shining to the sea,
And there is traffic on it and many a horse and cart,
But the little roads of Cloonagh are dearer far to me,
And the little roads of Cloonagh go rambling through my heart.

A great storm from the ocean goes shouting o'er the hill,
And there is glory in it and terror on the wind,
But the haunted air of twilight is very strange and still,
And the little winds of twilight are dearer to my mind.

The great waves of the Atlantic sweep storming on their way,
Shining green and silver with the hidden herring shoal;
But the little waves of Breffny have drenched my heart in spray,
And the little waves of Breffny go stumbling through my soul.

EVA GORE-BOOTH
1870-1926

To an Isle
in the Water

Shy one, shy one,
Shy one of my heart,
She moves in the firelight
Pensively apart.

She carries in the dishes,
And lays them in a row.
To an isle in the water
With her would I go.

She carries in the candles,
And lights the curtained room,
Shy in the doorway
And shy in the gloom;

And shy as a rabbit,
Helpful and shy.
To an isle in the water
With her would I fly.

WILLIAM BUTLER YEATS
1865-1939

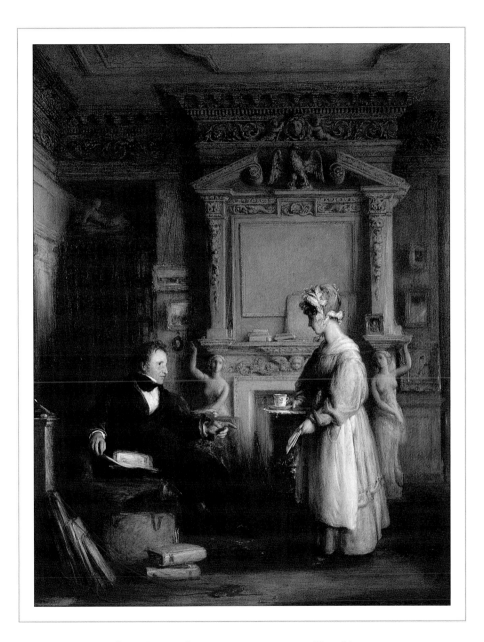

SIR JOHN SHEEPSHANKS AND HIS MAID

William Mulready

1786-1863

Everything Is Going To Be All Right

How should I not be glad to contemplate
the clouds clearing beyond the dormer window
and a high tide reflected on the ceiling?
There will be dying, there will be dying,
but there is no need to go into that.
The poems flow from the hand unbidden
and the hidden source is the watchful heart.
The sun rises in spite of everything
and the far cities are beautiful and bright.
I lie here in a riot of sunlight
watching the day break and the clouds flying.
Everything is going to be all right.

DEREK MAHON

1941-

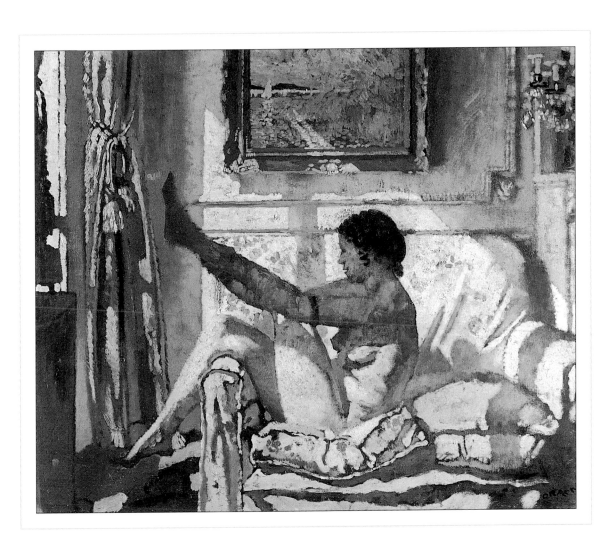

SUNLIGHT

Sir William Orpen

1878-1931

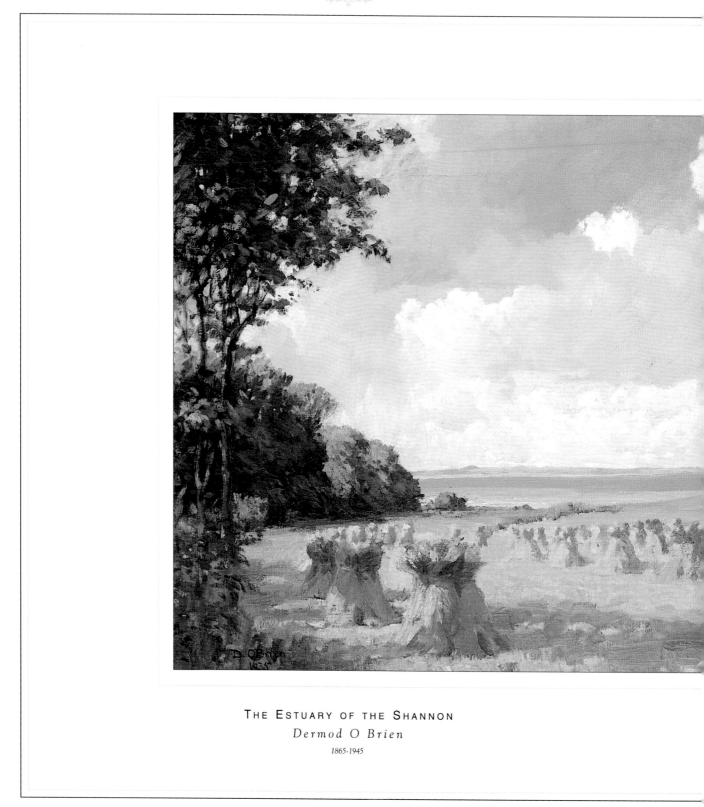

THE ESTUARY OF THE SHANNON
Dermod O Brien
1865-1945

My Land

She is a rich and rare land,
Oh she's a fresh and fair land;
She is a dear and rare land,
This native land of mine.

No men than hers are braver,
Her women's hearts ne'er waver;
I'd freely die to save her,
And think my lot divine.

She's not a dull or cold land,
No, she's a warm and bold land,
Oh, she's a true and old land,
This native land of mine.

Could beauty ever guard her,
And virtue still reward her,
No foe would cross her border –
No friend within it pine.

Oh, she's a fresh and fair land,
Oh, she's a true and rare land;
Yes she's a rare and fair land,
This native land of mine.

THOMAS DAVIS
1814-1845

D i d N o t

'Twas a new feeling – something more
Than we had dared to own before,
 Which then we hid not;
We saw it in each other's eye,
And wished, in every half-breathed sigh,
 To speak, but did not.

She felt my lips' impassioned touch –
'Twas the first time I dared so much,
 And yet she chid not;
But whispered o'er my burning brow,
'Oh, do you doubt I love you now?'
 Sweet soul! I did not.

Warmly I felt her bosom thrill,
I pressed it closer, closer still,
 Though gently bid not;
Till – oh! the world hath seldom heard
Of lovers, who so nearly erred,
 And yet, who did not.

THOMAS MOORE
1779-1852

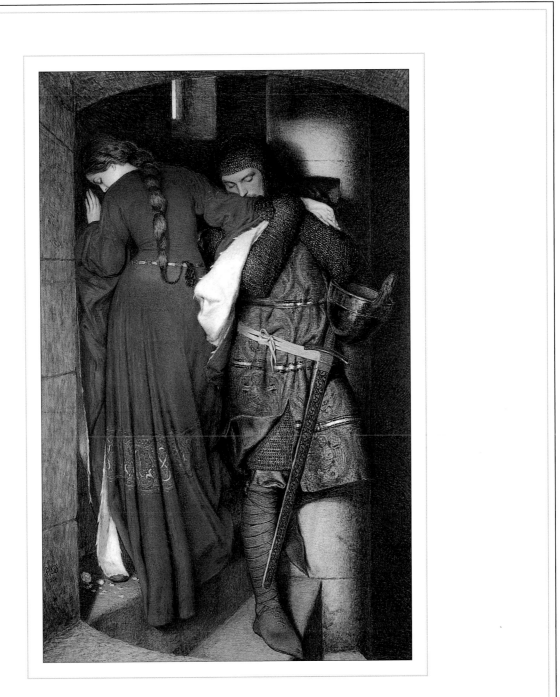

THE MEETING ON THE TURRET STAIRS
Sir Frederick Burton
1816-1900

Clever Tom Clinch Going to be Hanged

As clever Tom Clinch, while the rabble was bawling,
Rode stately through Holborn, to die in his calling;
He stopt at the George for a bottle of sack,
And promis'd to pay for it when he'd come back.
His waistcoat and stockings, and breeches were white,
His cap had a new cherry ribbon to tie't.
The maids to the doors and the balconies ran,
And said, lack-a-day! he's a proper young man.
But, as from the windows the ladies he spied,
Like a beau in the box, he bow'd low on each side;
And when his last speech the loud hawkers did cry,
He swore from his cart, it was all a damn'd lie.
The hangman for pardon fell down on his knee;
Tom gave him a kick in the guts for his fee.
Then said, I must speak to the people a little,
But I'll see you all damn'd before I will whittle.
My honest friend Wild, may he long hold his place,
He lengthen'd my life with a whole year of grace.
Take courage, dear comrades, and be not afraid,
Nor slip this occasion to follow your trade.
My conscience is clear, and my spirits are calm,
And thus I go off without Pray'r-Book or Psalm.
Then follow the practice of clever Tom Clinch,
Who hung like a hero, and never would flinch.

JONATHAN SWIFT
1667-1745

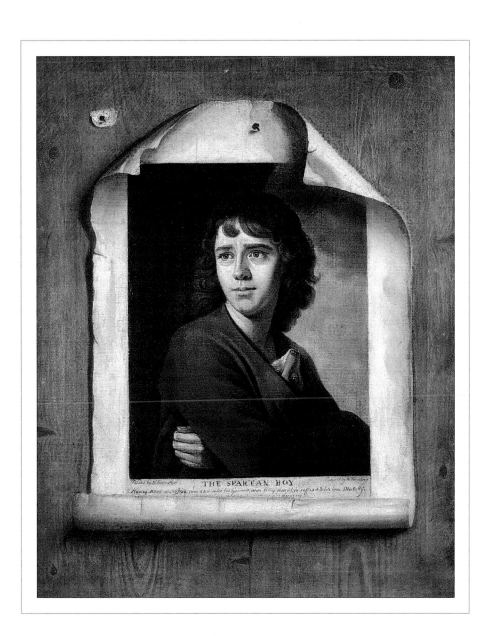

TROMPE L'OEIL OF AN ENGRAVING
BY NATHANIEL HONE ('THE SPARTAN BOY')
Irish School
c. 1800

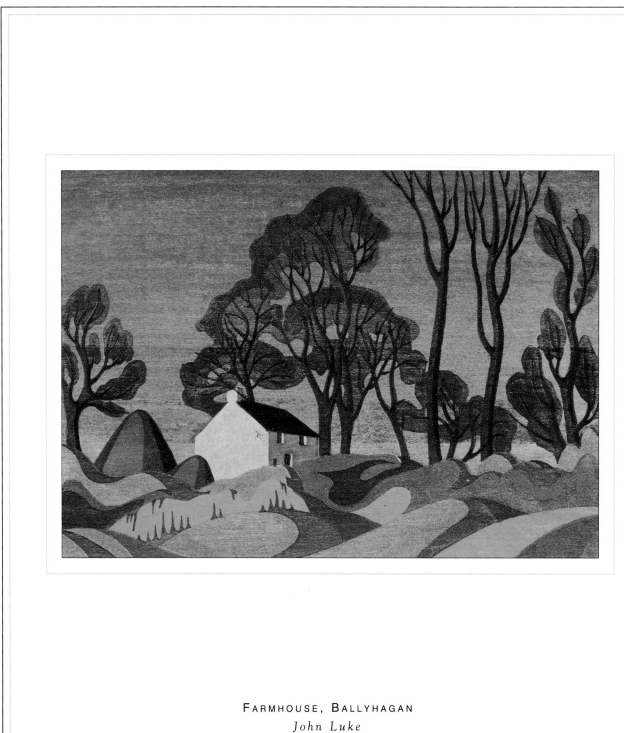

FARMHOUSE, BALLYHAGAN
John Luke
1906-1975

Breaking Wood

I was breaking wood in the shed
As dark fell. The wind gusted
And slammed the door, pitching
Me into such blackness that I
Missed my stroke and struck
A spark from the floor.

It brought back my father
Chopping wood in autumn,
And with it came the smell
Of leaf-mould, the hinted
Flights of late swallows,
The shrivelled gold

Of wasps in the notches
Of wide-spoked webs. Memories
Stilled me so long it was dark
Before I rose to gather the sticks.
A sigh of resin and I felt
The stirring of seeds of regret

As I tumbled the white wood
Into the rumbling box
And heard the wind whip
On the trees and bend into
A straight stream of lament
At the razored edge of the wall.

White fall of wood and blue-red
Leaping spark, pitch black
Blow of wind, dark inks
Of still and moving waters,
The seasonable deaths of summers,
The unseasonable deaths of fathers

Should I have struck with the axe
Near darkness, called the spark
From his deep energies of enrichment
And decay? Still, in this tangled weather
I must break sticks for warmth
And split the flinty wind

For its interior noises.
Soon the red honeycomb of fire
Will sting the poker bright
Up half its length. Soon
The fume of wood upon the air
Will take my feeling to the night.

SEAMUS DEANE
1940-

Believe Me, if all Those Endearing Young Charms

Believe me, if all those endearing young charms,
 Which I gaze on so fondly today,
Were to change by tomorrow, and fleet in my arms,
 Like fairy gifts, fading away,
Thou wouldst still be ador'd, as this moment thou art,
 Let thy loveliness fade as it will,
And around the dear ruin each wish of my heart
 Would entwine itself verdantly still.

It is not while beauty and youth are thine own,
 And thy cheeks unprofan'd by a tear,
That the fervour and faith of a soul can be known,
 To which time will but make thee more dear;
No, the heart that has truly lov'd never forgets,
 But as truly loves on to the close,
As the sunflower turns on her god, when he sets,
 The same look which she turn'd when he rose.

THOMAS MOORE

1779-1852

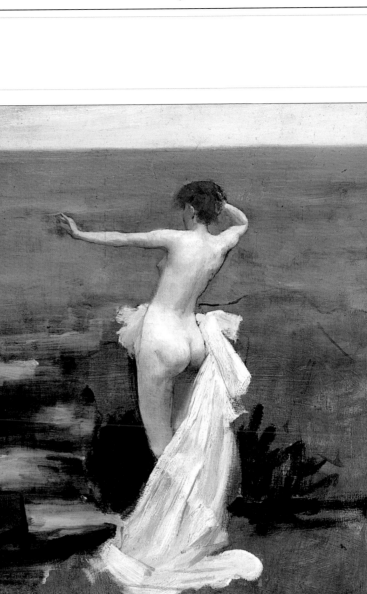

STUDY FOR ARIADNE

Sir John Lavery

1856-1941

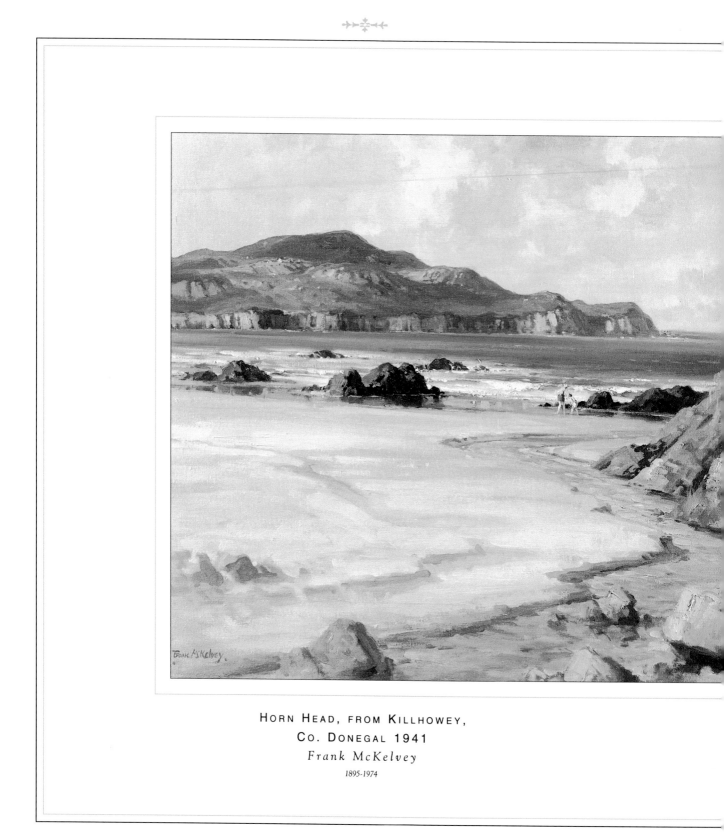

HORN HEAD, FROM KILLHOWEY,
CO. DONEGAL 1941
Frank McKelvey
1895-1974

Rock
Music

The ocean glittered quietly in the moonlight
While heavy metal rocked the discotheques;
Space-age Hondas farted half the night,
Fired by the prospect of fortuitous sex.
I sat late at the window, blind with rage,
And listened to the tumult down below,
Trying to concentrate on the printed page
As if such obsolete bumph could save us now.

Next morning, wandering on the strand, I heard
Left-over echoes of the night before
Dwindle to echoes, and a single bird
Drown with a whistle that residual roar.
Rock music started up on every side –
Whisper of algae, click of stone on stone,
A thousand limpets left by the ebb-tide
Unanimous in their silent inquisition.

DEREK MAHON
1941-

The Sorrow of Love

The quarrel of the sparrows in the eaves,
The full round moon and the star-laden sky,
And the loud song of the ever-singing leaves,
Had hid away earth's old and weary cry.

And then you came with those red mournful lips,
And with you came the whole of the world's tears,
And all the trouble of her labouring ships,
And all the trouble of her myriad years.

And now the sparrows warring in the eaves,
The curd-pale moon, the white stars in the sky,
And the loud chanting of the unquiet leaves,
Are shaken with earth's old and weary cry.

WILLIAM BUTLER YEATS

1865-1939

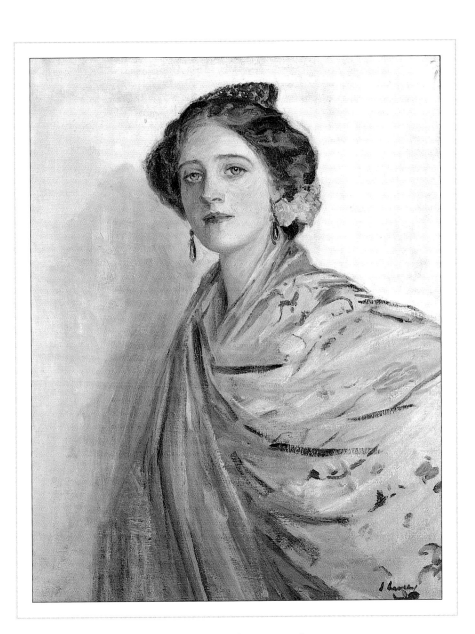

'A Fair Spaniard'
A Portrait of Mrs Chowne
Sir John Lavery
1856-1941

Pegasus

My soul was an old horse
Offered for sale in twenty fairs.
I offered him to the Church – the buyers
Were little men who feared his unusual airs.
One said: 'Let him remain unbid
In the wind and rain and hunger
Of sin and we will get him –
With the winkers thrown in – for nothing.'

Then the men of State looked at
What I'd brought for sale.
One minister, wondering if
Another horse-body would fit the tail
That he'd kept for sentiment –
The relic of his own soul –
Said, 'I will graze him in lieu of his labour.'
I lent him for a week or more
And he came back a hurdle of bones,
Starved, overworked, in despair.
I nursed him on the roadside grass
To shape him for another fair.

I lowered my price. I stood him where
The broken-winded, spavined stand
And crooked shopkeepers said that he
Might do a season on the land –
But not for high-paid work in towns.

He'd do a tinker, possibly.
I begged, 'O make some offer now,
A soul is a poor man's tragedy.
He'll draw your dungiest cart,' I said,
'Show you short cuts to Mass,
Teach weather lore, at night collect
Bad debts from poor men's grass.'
 And they would not.

 Where the
Tinkers quarrel I went down
With my horse, my soul.
I cried, 'Who will bid me half a crown?'
From their rowdy bargaining
Not one turned. 'Soul,' I prayed,
'I have hawked you through the world
Of Church and State and meanest trade.
But this evening, halter off,
Never again will it go on.
On the south side of ditches
There is grazing of the sun.
No more haggling with the world'

As I said these words he grew
Wings upon his back. Now I may ride him
Every land my imagination knew.

PATRICK KAVANAGH
1905-1967

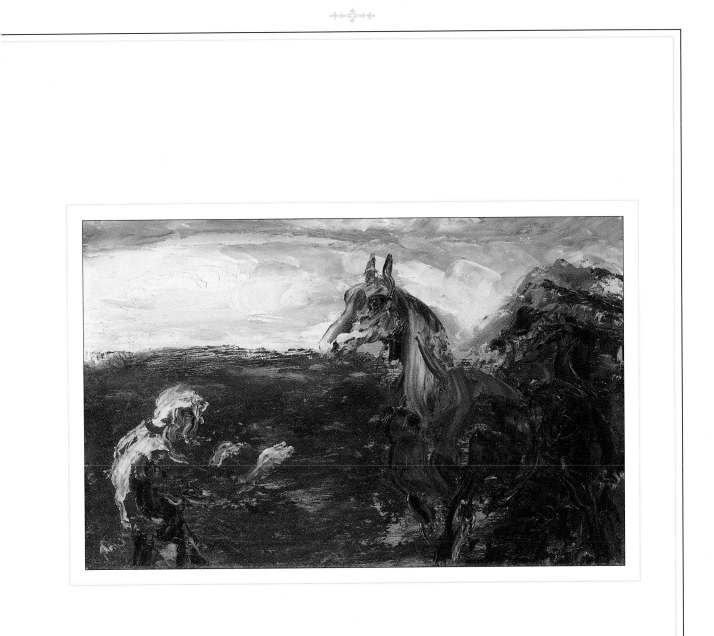

COME

Jack B. Yeats

1871-1957

The Lover Mourns for the Loss of Love

Pale brows, still hands and dim hair,
I had a beautiful friend
And dreamed that the old despair
Would end in love in the end:
She looked into my heart one day
And saw your image was there;
She has gone weeping away.

WILLIAM BUTLER YEATS
1865-1939

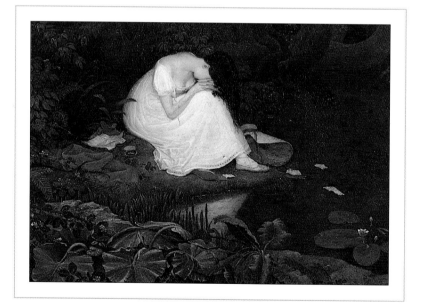

DISAPPOINTED LOVE (DETAIL)
Francis Danby
1793-1861

A Vagrant Heart

O to be a woman! to be left to pique and pine,
When the winds are out and calling to this vagrant heart of mine.
Whisht! it whistles at the windows, and how can I be still?
There! the last leaves of the beech-tree go dancing down the hill.
All the boats at anchor they are plunging to be free –
O to be a sailor, and away across the sea!
When the sky is black with thunder, and the sea is white with foam,
The grey gulls whirl up shrieking and seek their rocky home.
Low his boat is lying leeward, how she runs upon the gale,
As she rises with the billows, nor shakes her dripping sail.
There is danger on the waters – there is joy where dangers be –
Alas! to be a woman and the nomad's heart in me.

Ochone! to be a woman, only sighing on the shore –
With a soul that finds a passion for each long breaker's roar,
With a heart that beats as restless as all the winds that blow –
Thrust a cloth between her fingers, and tell her she must sew;
Must join in empty chatter, and calculate with straws –
For the weighing of our neighbour – for the sake of social laws.
O chatter, chatter, chatter, when to speak is misery,
When silence lies around your heart – and night is on the sea.
So tired of little fashions that are root of all our strife,
Of all the petty passions that upset the calm of life.
The law of God upon the land shines steady for all time;
The laws confused that man has made, have reason not nor rhyme.

O bird that fights the heavens, and is blown beyond the shore,
Would you leave your flight and danger for a cage to fight no more?
No more the cold of winter, or the hunger of the snow,
Nor the winds that blow you backward from the path you wish to go?
Would you leave your world of passion for a home that knows no riot?
Would I change my vagrant longings for a heart more full of quiet?
No! – for all its dangers, there is joy in danger too:
On, bird, and fight your tempests, and this nomad heart with you!

The seas that shake and thunder will close our mouths one day,
The storms that shriek and whistle will blow our breaths away.
The dust that flies and whitens will mark not where we trod.
What matters then our judging? we are face to face with God.

DORA SIGERSON
1866-1918

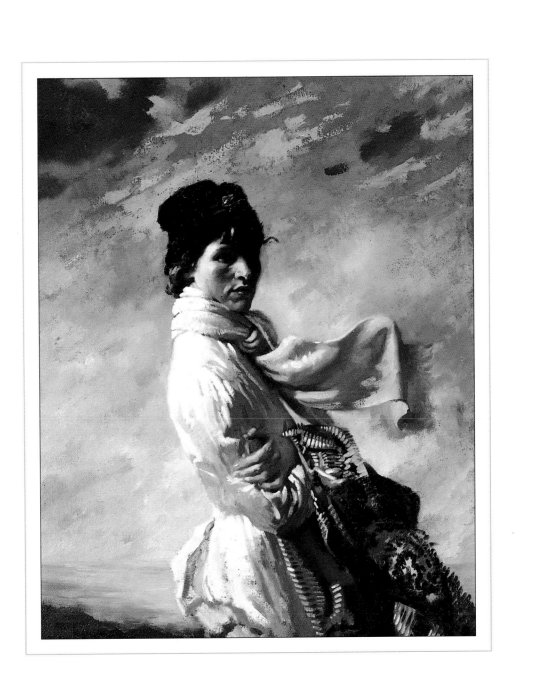

IN DUBLIN BAY

Sir William Orpen

1878-1931

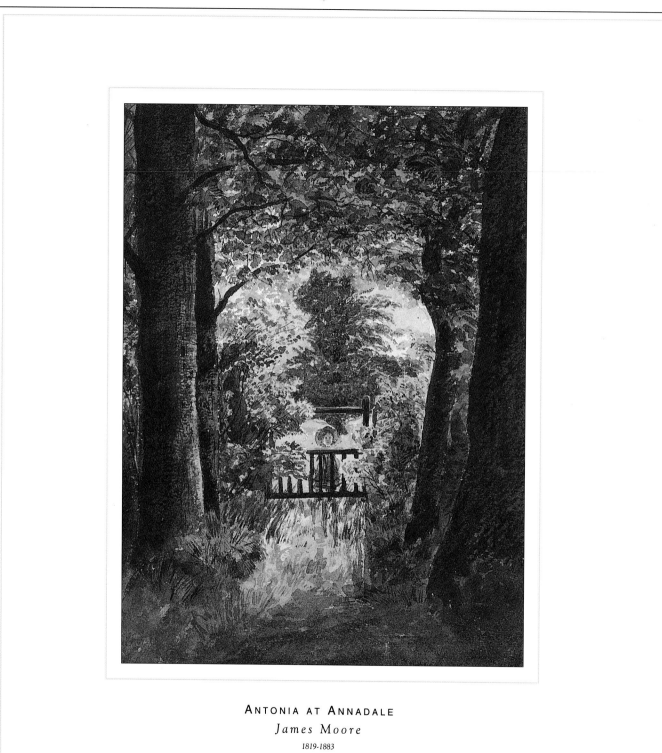

ANTONIA AT ANNADALE

James Moore

1819-1883

Cliona

for Claire

You are letting her go
from you slowly
so gently she hardly
knows.
She unties you like
an apron,
puts you on again.
Watching her grow
is catching yourself
after years, hearing
your own voice.

In sunlight
she returns to you
from her swim
to be dried.

Little fish.
You remember the bowl
of your womb, the ocean
that held her where
you felt her swim.

You are letting her out
now, loosening
like a kite's string
seeing her for the first
time in her own orbit
in the drive, cycling.

CATHERINE TWOMEY
1960-

A Refusal to Mourn

He lived in a small farm-house
At the edge of a new estate.
The trim gardens crept
To his door, and car engines
Woke him before dawn
On dark winter mornings.

All day there was silence
In the bright house. The clock
Ticked on the kitchen shelf,
Cinders moved in the grate,
And a warm briar gurgled
When the old man talked to himself;

But the door-bell seldom rang
After the milkman went,
And if a shirt-hanger
Knocked in an open wardrobe
That was a strange event
To be pondered on for hours

While the wind thrashed about
In the back garden, raking
The roof of the hen-house,
And swept clouds and gulls
Eastwards over the lough
With its flap of tiny sails.

Once a week he would visit
An old shipyard crony,
Inching down the road
And the blue country bus
To sit and watch sun-dappled
Branches whacking the windows

While the long evening shed
Weak light in his empty house,
On the photographs of his dead
Wife and their six children
And the Missions to Seamen angel
In flight above the bed.

'I'm not long for this world,'
Said he on our last evening,
'I'll not last the winter,'
And grinned, straining to hear
Whatever reply I made;
And died the following year.

In time the astringent rain
Of those parts will clean
The words from his gravestone
In the crowded cemetery
That overlooks the sea
And his name be mud once again

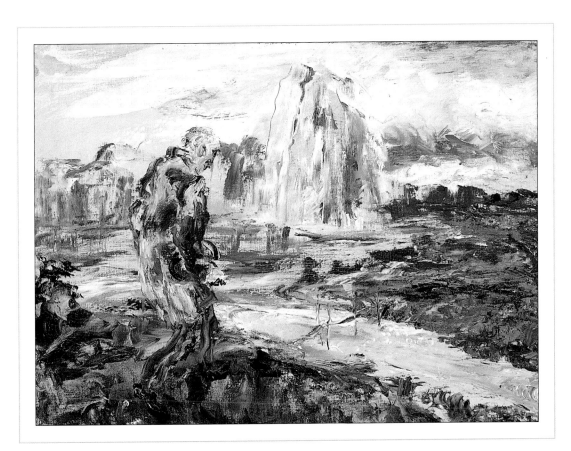

ON THROUGH SILENT LANDS
Jack B. Yeats
1871-1957

And his boilers lie like tombs
In the mud of the sea bed
Till the next ice age comes
And the earth he inherited
Is gone like Neanderthal Man
And no records remain.

But the secret bred in the bone
On the dawn strand survives
In other times and lives,
Persisting for the unborn
Like a claw-print in concrete
After the bird has flown.

DEREK MAHON
1941-

Irish Lullaby

I'd rock my own sweet childie to rest in a cradle of gold on a bough of the willow,
To the shoheen ho of the wind of the west and the lulla lo of the soft sea billow.
 Sleep, baby dear,
 Sleep without fear,
 Mother is here beside your pillow.

I'd put my own sweet childie to sleep in a silver boat on the beautiful river,
Where a shoheen whisper the white cascades, and a lulla lo the green flags shiver.
 Sleep, baby dear,
 Sleep without fear
 Mother is here with you for ever.

Lull lo! to the rise and fall of mother's bosom 'tis sleep has bound you,
And O, my child, what cosier nest for rosier rest could love have found you?
 Sleep, baby dear,
 Sleep without fear,
 Mother's two arms are clasped around you.

ALFRED PERCIVAL GRAVES
1846-1931

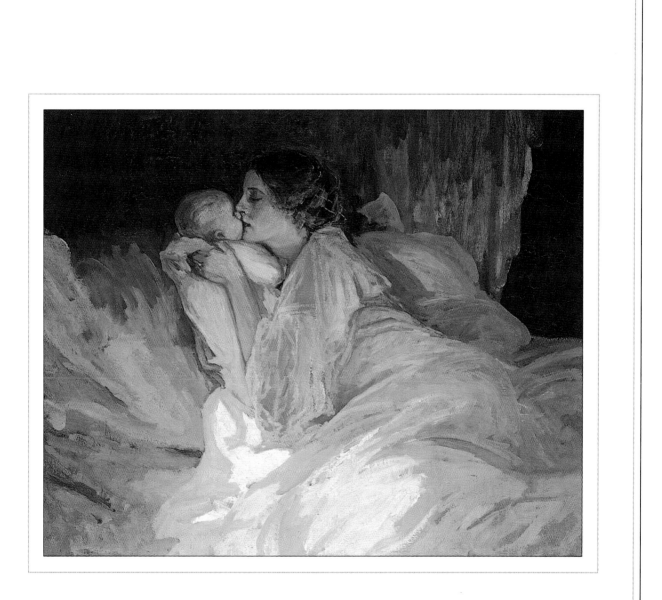

THE MOTHER

Sir John Lavery

1856-1941

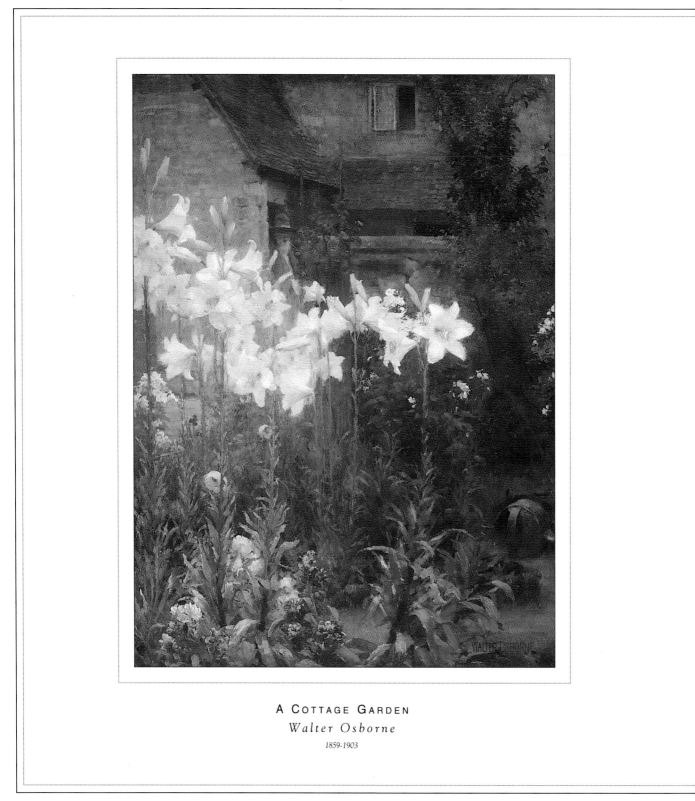

A COTTAGE GARDEN

Walter Osborne

1859-1903

A Day
in August

And still no stronger. Swathed in rugs he lingered
 Near to the windows, gauging distant hills.
Balked by the panes that promised light and flowers,
 The wasps were dying furiously on sills.

A doctor called. She walked him to the doorstep,
 Then sent the children out to gather cones
Under the trees beside the ruined churchyard.
 They romped, unheeding, in the tilted stones.

And now the wheels are turning. They impress
 Tracks that will not outlast the winter's rain.
The siren leaves a wash of emptiness.
 He is lost to the small farms, lane by lane.

FRANK ORMSBY
1947-

Windharp

for Patrick Collins

The sounds of Ireland,
that restless whispering
you never get away
from, seeping out of
low bushes and grass,
heatherbells and fern,
wrinkling bog pools,
scraping tree branches,
light hunting cloud,
sound hounding sight,
a hand ceaselessly
combing and stroking
the landscape, till
the valley gleams
like the pile upon
a mountain pony's coat.

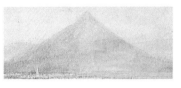

JOHN MONTAGUE
1929-

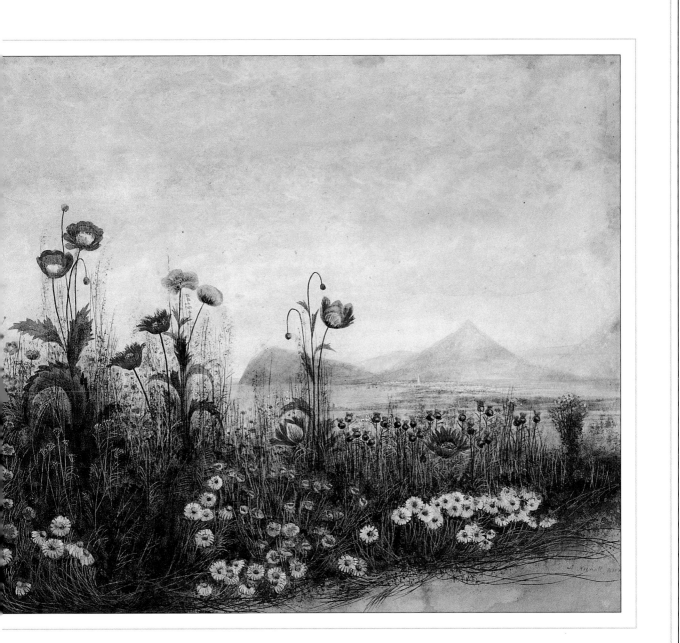

A BANK OF FLOWERS
Andrew Nicholl
1804-1886

No Second
Troy

Why should I blame her that she filled my days
With misery, or that she would of late
Have taught to ignorant men most violent ways,
Or hurled the little streets upon the great,
Had they but courage equal to desire?
What could have made her peaceful with a mind
That nobleness made simple as a fire,
With beauty like a tightened bow, a kind
That is not natural in an age like this,
Being high and solitary and most stern?
Why, what could she have done, being what she is?
Was there another Troy for her to burn?

WILLIAM BUTLER YEATS

1865-1939

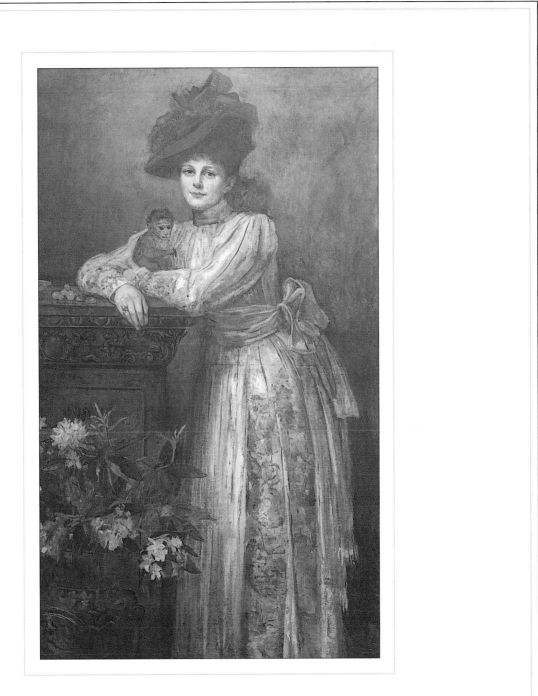

MISS MAUD GONNE
Sarah Henrietta Purser
1848-1943

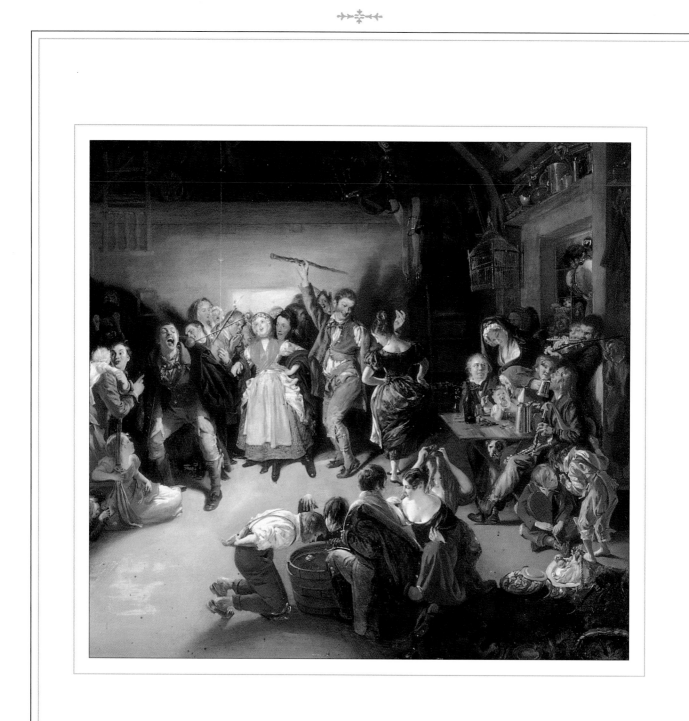

SNAP APPLE NIGHT (DETAIL)

Daniel Maclise

1806-1870

from
The Traveller

Eternal blessings crown my earliest friend,
And round his dwelling guardian saints attend;
Blest be that spot, where chearful guests retire
To pause from toil, and trim their evening fire;
Blest that abode, where want and pain repair,
And every stranger finds a ready chair;
Blest be those feasts with simple plenty crown'd,
Where all the ruddy family around
Laugh at the jests and pranks that never fail,
Or sigh with pity at some mournful tale,
Or press the bashful stranger to his food,
And learn the luxury of doing good.

OLIVER GOLDSMITH

1728(?)-1774

The Lady of the Restaurant

Of all the womenfolk I knew
The lush, the gamey-eyed, the gaunt
Not one could hold a candle to
The Lady of the Restaurant.

In Limerick city I sat down
A-weary of the stranger's face
For 'tis a pain to be alone
In such a populated place.

I asked a man who chanced to pass
If he could recommend to me
A place where I could break my fast
And drink a mug or two of tea.

He pointed and I wandered in
Where there were lights and people sat
By china-covered table cloths
Passing the hours in idle chat.

There as I tilted up the cup
And gorged my belly out of want
Who should I see there looking up:
The Lady of the Restaurant!

I whispered low, now child of grace
What a predicament you're in
With muddy lanes writ on your face
And hairy acres on your chin,

For could you but have seen her, boys
With health or wealth you'd gladly part
Or with your wisdom if you're wise
To set her image on your heart.

Within her love and beauty lurk
Her hair is pressed into a bun
No daubing brush's handiwork
Would dare to tarnish such a one.

O boys, my wonder was threefold
To see a mouth so ripe and sweet
A limb that had so fine a mould
The fluted leather on her feet.

All things shall come to one who waits
By god I waited far too long
Around me were the nodding pates
But she had vanished in the throng.

For me the Fates select such tricks
I drank no more when she was gone
She was a siren of twenty-six
And I a year of twenty-one.

SEAN O'MEARA
1933-

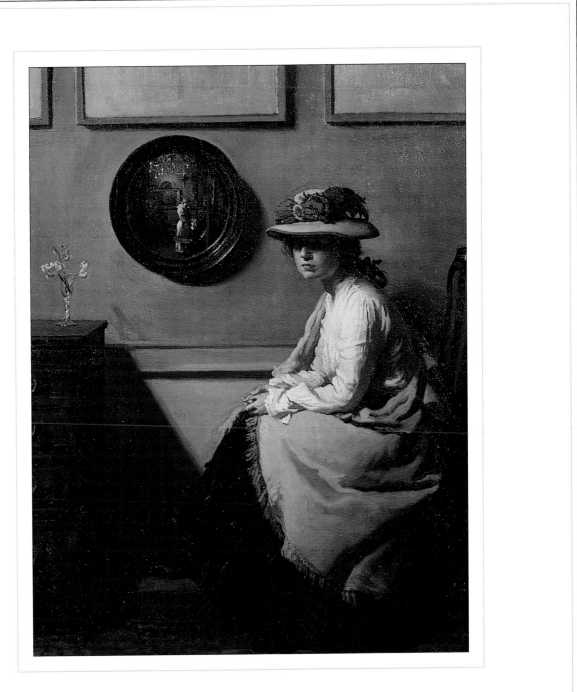

THE MIRROR
Sir William Orpen
1878-1931

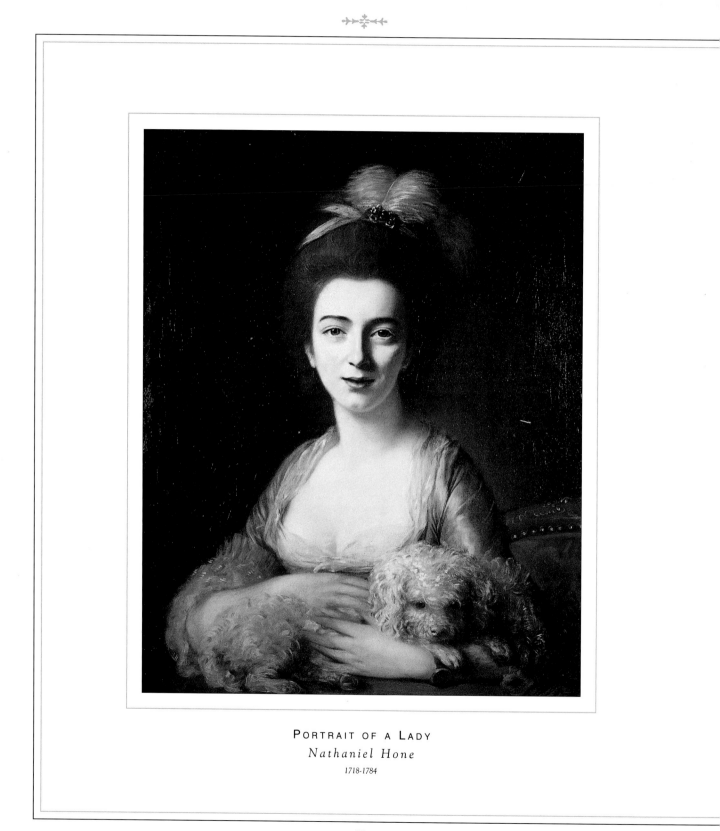

PORTRAIT OF A LADY
Nathaniel Hone
1718-1784

Stella's Birthday

Stella this day is thirty-four,
(We shan't dispute a year or more):
However Stella, be not troubled,
Although thy size and years are doubled,
Since first I saw thee at sixteen,
The brightest virgin on the green;
So little is thy form declined
Made up so largely in thy mind.

 Oh, would it please the gods to split
Thy beauty, size, and years, and wit,
No age could furnish out a pair
Of nymphs so graceful, wise and fair:
With half the lustre of your eyes,
With half your wit, your years, and size:
And then before it grew too late,
How should I beg of gentle fate,
(That either nymph might have her swain),
To split my worship too in twain.

JONATHAN SWIFT
1667-1745

Knockmany

Knockmany, my darling, I see you again,
As the sunrise has made you a King;
And your proud face looks tenderly down on the plain
Where my young larks are learning to sing.

At your feet lies our vale, but sure that's no disgrace.
If your arms had their will, they would cover
Every inch of the ground, from Dunroe to Millrace,
With the sweet silent care of a lover.

To that green heart of yours have I stolen my way
With my first joy and pain and misgiving.
Dear Mountain! old friend, ah! I would that today
You could thus share the life I am living.

For one draught of your breath would flow into my heart,
Like the rain to the thirsty green corn;
And I know 'neath your smile all my cares would depart
As the night shadows flee from the morn.

ROSE KAVANAGH
1859-1891

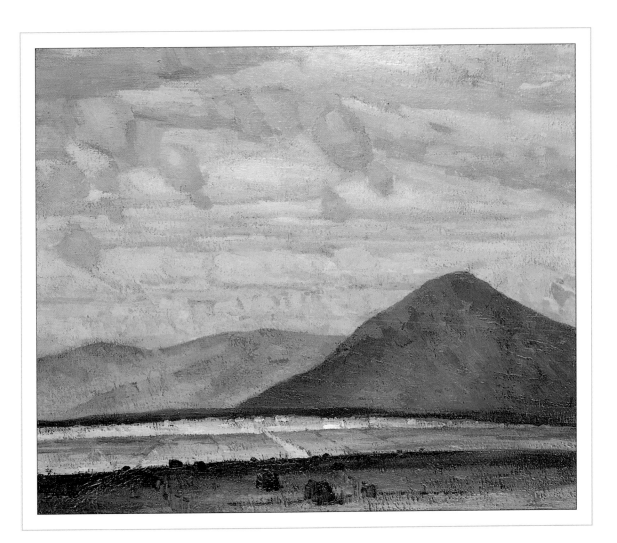

ON ACHILL ISLAND
Charles Vincent Lamb
1893-1964

The Cage

My father, the least happy
man I have known. His face
retained the pallor
of those who work underground:
the lost years in Brooklyn
listening to a subway
shudder the earth.

But a traditional Irishman
who (released from his grille
in the Clark St I.R.T.)
drank neat whiskey until
he reached the only element
he felt at home in
any longer: brute oblivion.

And yet picked himself
up, most mornings,
to march down the street
extending his smile
to all sides of the good
(non-negro) neighbourhood
belled by St Teresa's church.

When he came back
we walked together
across fields of Garvaghey
to see hawthorn on the summer
hedges, as though
he had never left;
a bend of the road

which still sheltered
primroses. But we
did not smile in
the shared complicity
of a dream, for when
weary Odysseus returns
Telemachus must leave.

Often as I descend
into subway or underground
I see his bald head behind
the bars of the small booth;
the mark of an old car
accident beating on his
ghostly forehead.

JOHN MONTAGUE
1929-

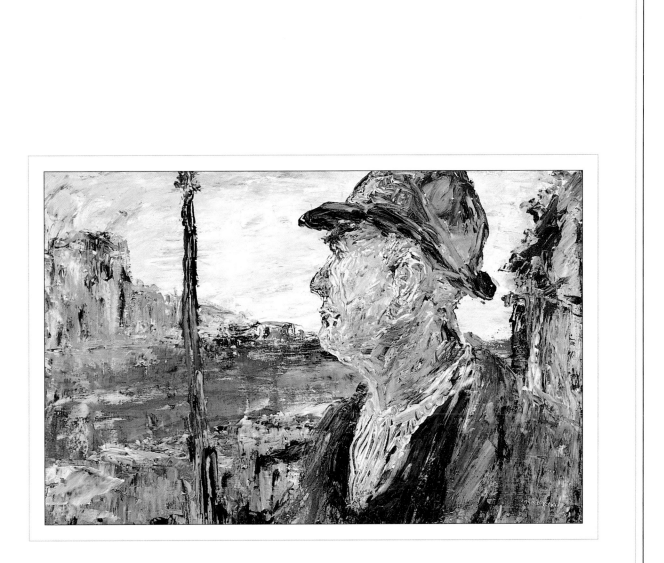

MARTIN
Jack B. Yeats
1871-1957

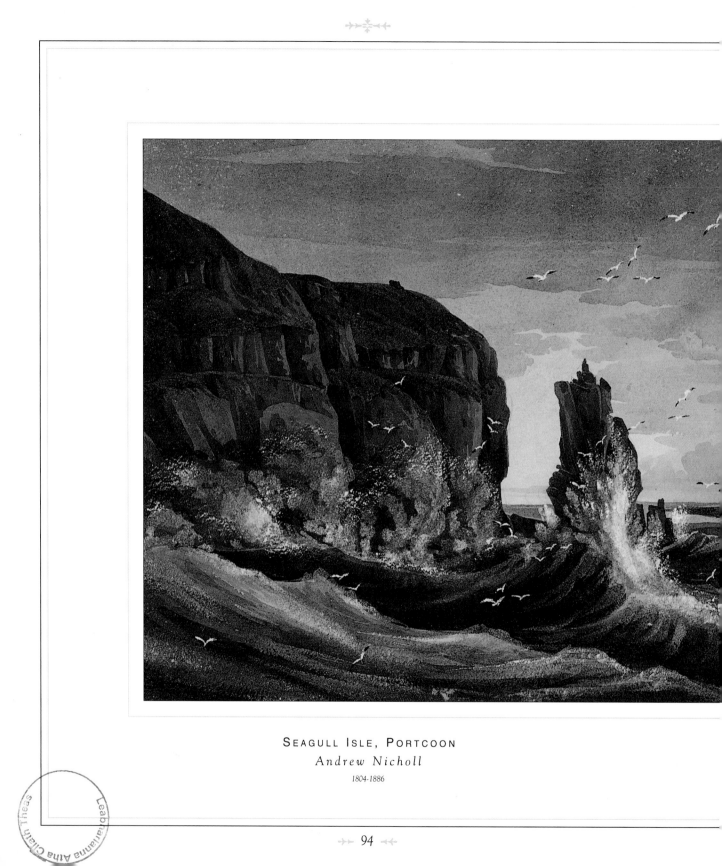

SEAGULL ISLE, PORTCOON
Andrew Nicholl
1804-1886

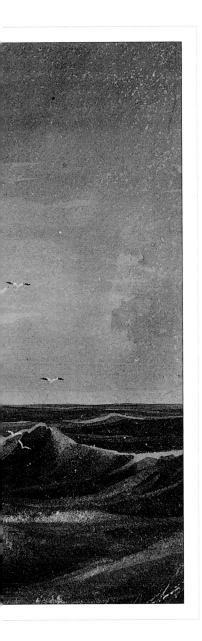

The Sea

Incorrigible, ruthless,
It rattled the shingly beach of my childhood,
Subtle, the opposite of earth,
And, unlike earth, capable
Any time at all of proclaiming eternity
Like something or someone to whom
We have to surrender, finding
Through that surrender life.

From Nature Notes
LOUIS MACNEICE
1907-1963

Peace

And sometimes I am sorry when the grass
Is growing over the stones in quiet hollows
And the cocksfoot leans across the rutted cart-pass
That I am not the voice of country fellows
Who now are standing by some headland talking
Of turnips and potatoes or young corn
Or turf banks stripped for victory.
Here Peace is still hawking
His coloured combs and scarves and beads of horn.

Upon a headland by a whiny hedge
A hare sits looking down a leaf-lapped furrow,
There's an old plough upside-down on a weedy ridge
And someone is shouldering home a saddle-harrow.
Out of that childhood country what fools climb
To fight with tyrants Love and Life and Time?

PATRICK KAVANAGH
1905-1967

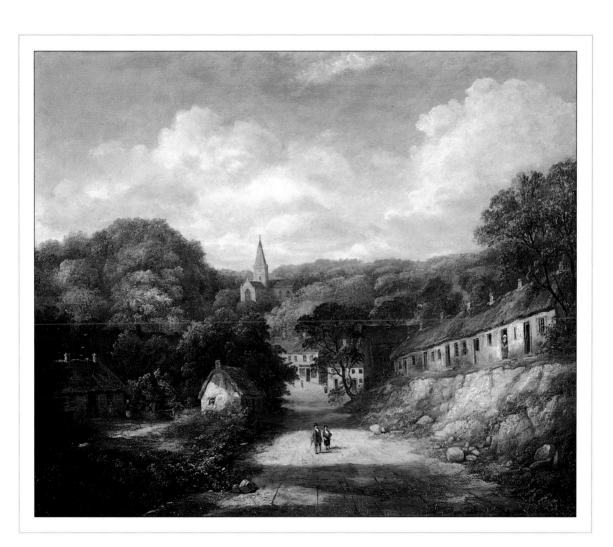

VIEW OF WARINGSTOWN, CO. DOWN
Hugh Frazer
c.1795-1861

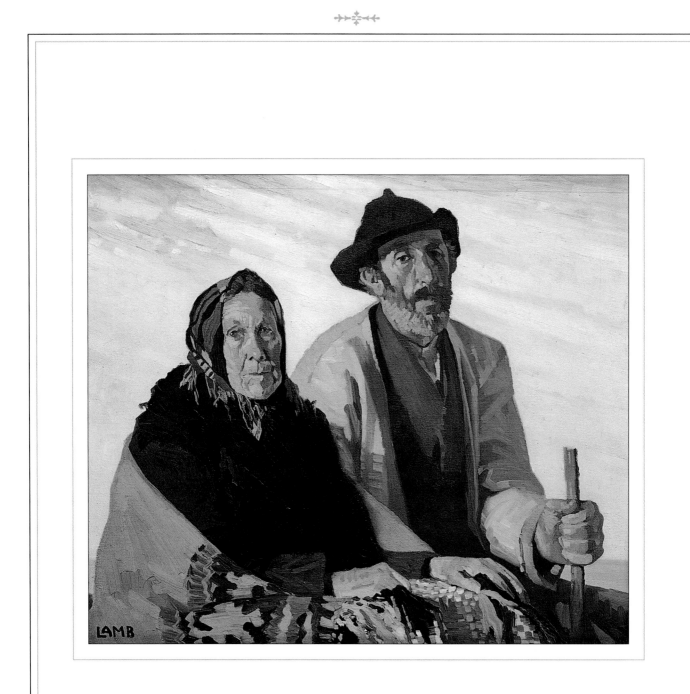

THE QUAINT COUPLE
Charles Vincent Lamb
1893-1964

Like Dolmens Round My Childhood, the Old People

Like dolmens round my childhood, the old people.

Jamie MacCrystal sang to himself,
A broken song without tune, without words;
He tipped me a penny every pension day,
Fed kindly crusts to winter birds.
When he died, his cottage was robbed,
Mattress and money box torn and searched.
Only the corpse they didn't disturb.

Maggie Owens was surrounded by animals,
A mongrel bitch and shivering pups,
Even in her bedroom a she-goat cried.
She was a well of gossip defiled,
Fanged chronicler of a whole countryside:
Reputed a witch, all I could find
Was her lonely need to deride.

The Nialls lived along a mountain lane
Where heather bells bloomed, clumps of foxglove.
All were blind, with Blind Pension and Wireless,
Dead eyes serpent-flicked as one entered
To shelter from a downpour of mountain rain.
Crickets chirped under the rocking hearthstone
Until the muddy sun shone out again.

Mary Moore lived in a crumbling gatehouse,
Famous as Pisa for its leaning gable.
Bag-apron and boots, she tramped the fields
Driving lean cattle from a miry stable.
A by-word for fierceness, she fell asleep
Over love stories, Red Star and Red Circle,
Dreamed of gypsy love rites, by firelight sealed.

Wild Billy Eagleson married a Catholic servant girl
When all his Loyal family passed on:
We danced round him shouting 'To Hell with King Billy,'
And dodged from the arc of his flailing blackthorn.
Forsaken by both creeds, he showed little concern
Until the Orange drums banged past in the summer
And bowler and sash aggressively shone.

Curate and doctor trudged to attend them,
Through knee-deep snow, through summer heat,
From main road to lane to broken path,
Gulping the mountain air with painful breath.
Sometimes they were found by neighbours,
Silent keepers of a smokeless hearth,
Suddenly cast in the mould of death.

Ancient Ireland, indeed! I was reared by her bedside,
The rune and the chant, evil eye and averted head,
Fomorian fierceness of family and local feud.
Gaunt figures of fear and of friendliness,
For years they trespassed on my dreams,
Until once, in a standing circle of stones,
I felt their shadows pass

Into that dark permanence of ancient forms.

<div align="center">JOHN MONTAGUE</div>
<div align="center">1929-</div>

O Country
People

O country people, you of the hill farms,
huddled so in darkness I cannot tell
whether the light across the glen is a star,
or the bright lamp spilling over the sill,
I would be neighbourly, would come to terms
with your existence, but you are so far;
there is a wide bog between us, a high wall.
I've tried to learn the smaller parts of speech
in your slow language, but my thoughts need more
flexible shapes to move in, if I am to reach
into the hearth's red heart across the half-door.

You are coarse to my senses, to my washed skin;
I shall maybe learn to wear dung on my heel,
but the slow assurance, the unconscious discipline
informing your vocabulary of skill,
is beyond my mastery, who have followed a trade
three generations now, at counter and desk;
hand me a rake, and I at once, betrayed,
will shed more sweat than is needed for the task.

If I could gear my mind to the year's round,
take season into season without a break,
instead of feeling my heart bound and rebound
because of the full moon or the first snowflake,
I should have gained something. Your secret is pace.
Already in your company I can keep step,
but alone, involved in a headlong race,
I never know the moment when to stop.

I know the level you accept me on,
like a strange bird observed about the house,
or sometimes seen out flying on the moss
that may tomorrow, or next week, be gone,
liable to return without warning
on a May afternoon and away in the morning.

But we are no part of your world, your way,
as a field or a tree is, or a spring well.
We are not held to you by the mesh of kin;
we must always take a step back to begin,
and there are many things you never tell
because we would not know the things you say.

I recognize the limits I can stretch;
even a lifetime among you should leave me strange,
for I could not change enough, and you will not change;
there'd still be levels neither'd ever reach.
And so I cannot ever hope to become,
for all my goodwill toward you, yours to me,
even a phrase or a story which will come
pat to the tongue, part of the tapestry
of apt response, at the appropriate time,
like a wise saw, a joke, an ancient rime
used when the last stack's topped at the day's end,
or when the last lint's carted round the bend.

JOHN HEWITT
1907-

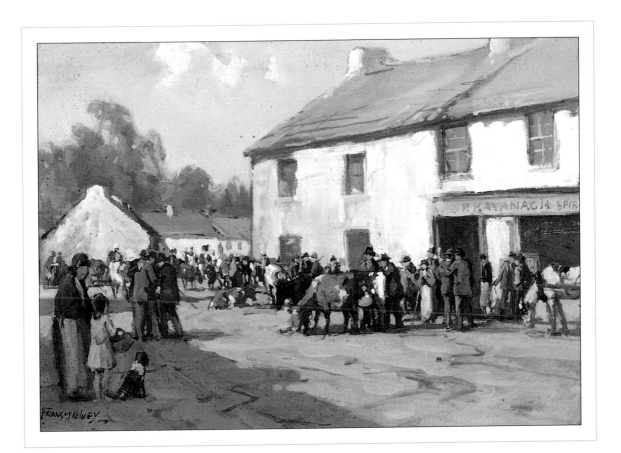

A FAIR IN COUNTY ANTRIM

Frank McKelvey

1895-1974

Wild Geese

(A lament for Irish Jacobites)

I have heard the curlew crying
 On a lonely moor and mere;
And the sea-gull's shriek in the gloaming
 Is a lonely sound in the ear:
And I've heard the brown thrush mourning
 For her children stolen away;–
But it's O for the homeless Wild Geese
 That sailed ere the dawn of day!

For the curlew out on the moorland
 Hath five fine eggs in the nest;
And the thrush will get her a new love
 And sing her song with the best.
As the swallow flies to the Summer
 Will the gull return to the sea:
But never the wings of the Wild Geese
 Will flash over seas to me.

And 'tis ill to be roaming, roaming
 With homesick heart in the breast!
And how long I've looked for your coming,
 And my heart is the empty nest!
O sore in the land of the stranger
 They'll pine for the land far away!
But day of Aughrim, my sorrow,
 It was you was the bitter day!

KATHARINE TYNAN
1861-1931

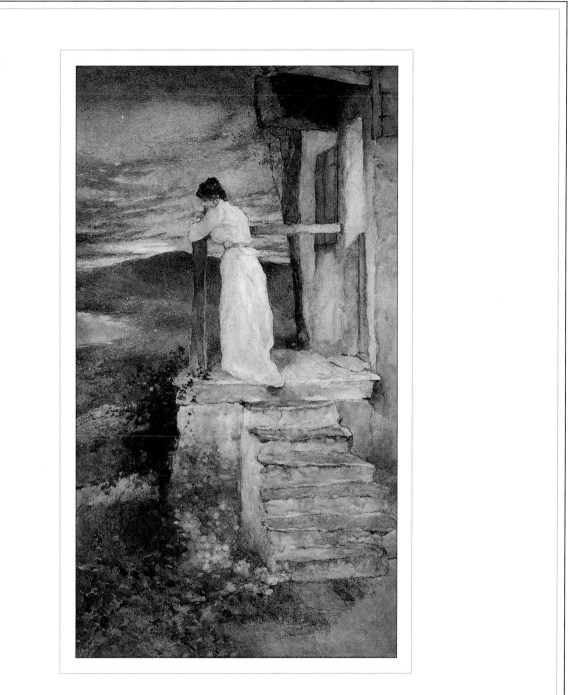

AWAITING THE SAILOR'S RETURN
David Woodlock
1842-1929

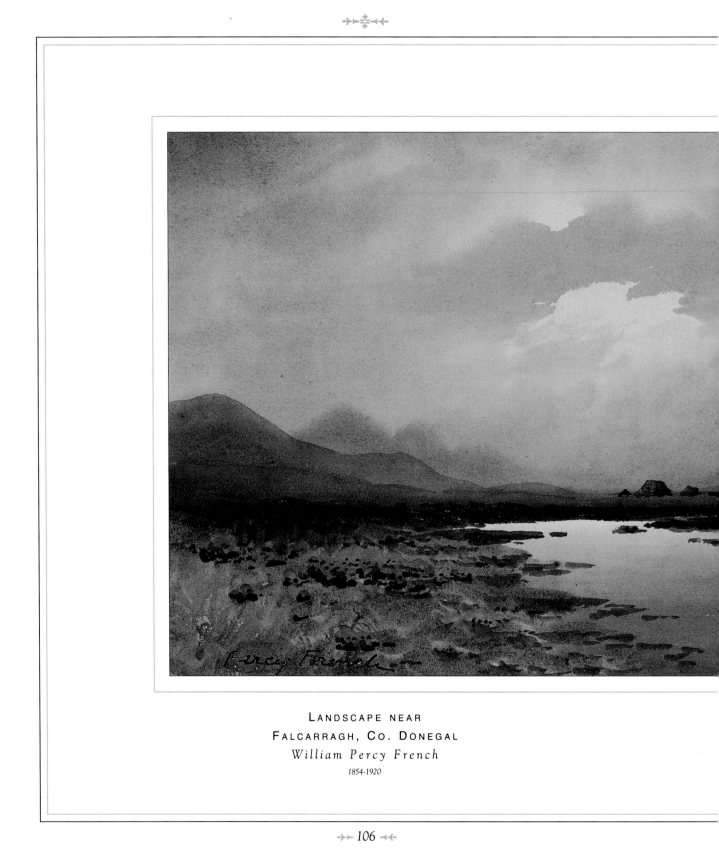

LANDSCAPE NEAR
FALCARRAGH, CO. DONEGAL
William Percy French
1854-1920

Ireland

'Twas the dream of a God,
 And the mould of His hand,
That you shook 'neath His stroke,
That you trembled and broke
 To this beautiful land.

Here He loosed from His hold
 A brown tumult of wings,
Till the wind on the sea
Bore the strange melody
 Of an island that sings.

He made you all fair,
 You in purple and gold,
You in silver and green,
Till no eye that has seen
 Without love can behold.

I have left you behind
 In the path of the past,
With the white breath of flowers,
With the best of God's hours,
 I have left you at last.

DORA SIGERSON
1866-1918

Thee, Thee, only Thee

The dawning of morn, the daylight's sinking,
The night's long hours still find me thinking
 Of thee, thee, only thee.
When friends are met, and goblets crowned,
 And smiles are near, that once enchanted,
Unreached by all that sunshine round,
 My soul, like some dark spot, is haunted
 By thee, thee, only thee.

Whatever in fame's high path could waken
My spirit once, is now forsaken
 For thee, thee, only thee.
Like shores, by which some headlong bark
 To the ocean hurries – resting never –
Life's scenes go by me, bright or dark,
 I know not, heed not, hastening ever
 To thee, thee, only thee.

I have not a joy but of thy bringing,
And pain itself seems sweet, when springing
 From thee, thee, only thee.
Like spells, that nought on earth can break,
 Till lips that know the charm have spoken,
This heart, however the world may wake
 Its grief, its scorn, can but be broken
 By thee, thee, only thee.

THOMAS MOORE
1779-1852

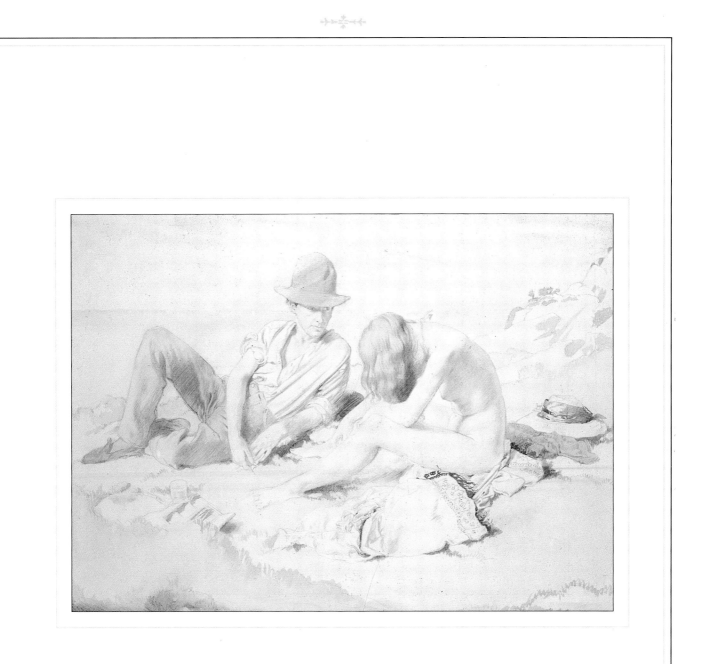

THE DRAUGHTSMAN AND HIS MODEL
Sir William Orpen
1878-1931

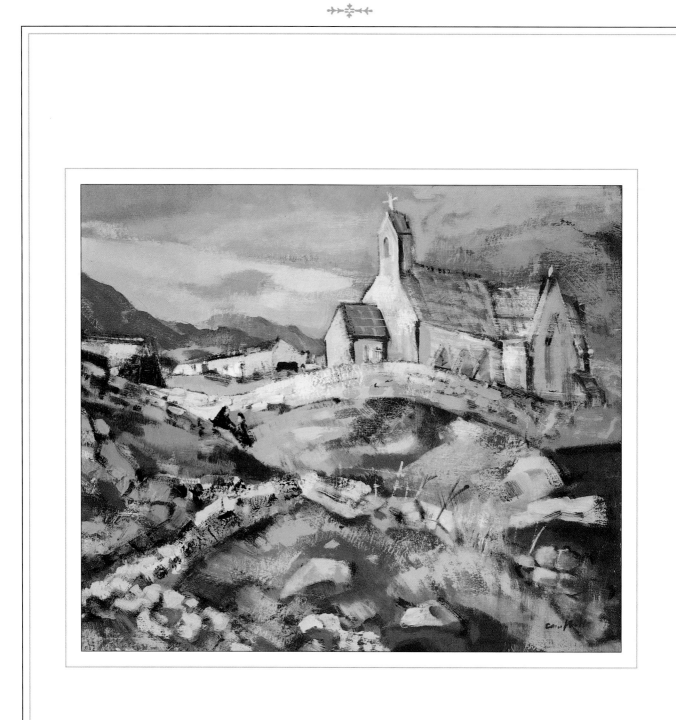

CLADDAGH DUFF, CONNEMARA
George Campbell
1917-1979

The Mass is Over

The Mass is over, they have gone in peace
But wind flays the church's sides
I fear my frail cover will be blown
Despite the sunlight on confessional doors,
Desultory coins,
The urgent reaching of the women's prayers.

I have taken refuge from a bitter shower
And find myself at Christ's fire
Yearning for things I've had
And won't have again
Because I have done wrong;
He passes – and a shudder of sparks
Ignites the recognition,
A dark object in a field of light
Where I have come for shelter
And in the warm eye of the wind
My twenty Easters wash me in their milky sun.

SARA BERKELEY
1967-

Prayer for a Child

God keep my jewel this day from danger;
From tinker and pooka and black-hearted stranger.
From harm of the water, from hurt of the fire.
From the horns of the cows going home to the byre.
From the sight of the fairies that maybe might change her.
From teasing the ass when he's tied to the manger.
From stones that would bruise her, from thorns of the briar.
From evil red berries that wake her desire.
From hunting the gander and vexing the goat.
From the depths o' sea water by Danny's old boat.
From cut and from tumble, from sickness and weeping;
May God have my jewel this day in his keeping.

WINIFRED M. LETTS

1882-1973

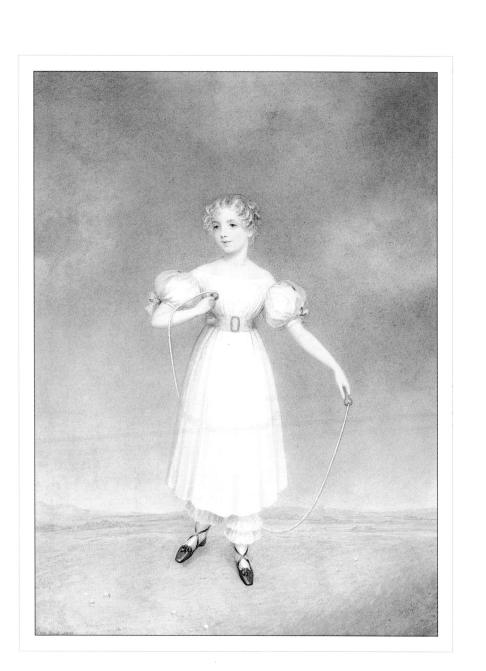

ANNIE CHARLOTTE HILL
Adam Buck
1759-1833

The Trout

Flat on the bank I parted
Rushes to ease my hands
In the water without a ripple
And tilt them slowly downstream
To where he lay, tendril light,
In his fluid sensual dream.

Bodiless lord of creation
I hung briefly above him
Savouring my own absence
Senses expanding in the slow
Motion, the photographic calm
That grows before action.

As the curve of my hands
Swung under his body
He surged, with visible pleasure.
I was so preternaturally close
I could count every stipple
But still cast no shadow, until

The two palms crossed in a cage
Under the lightly pulsing gills.
Then (entering my own enlarged
Shape, which rode on the water)
I gripped. To this day I can
Taste his terror on my hands.

JOHN MONTAGUE
1929-

CONNEMARA LANDSCAPE

Ray Gillespie

1955-

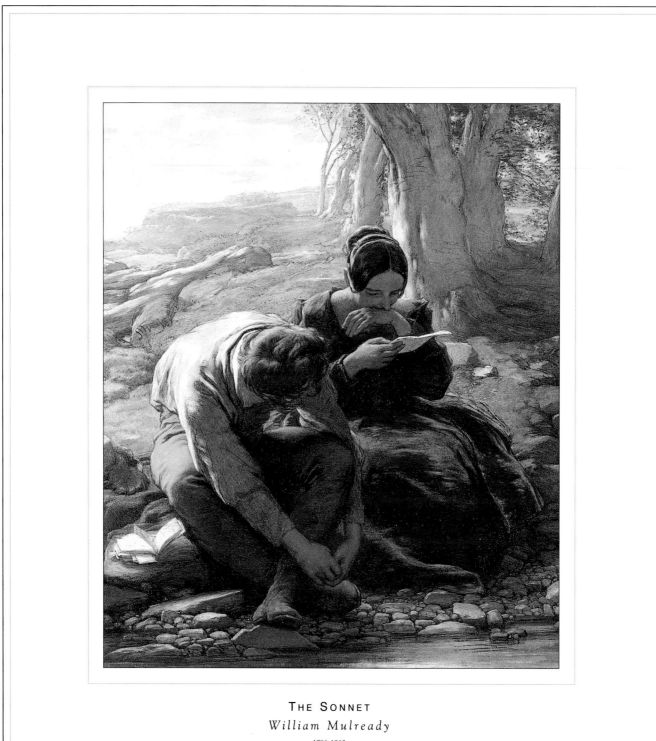

THE SONNET

William Mulready

1786-1863

A Poet
to his Beloved

I bring you with reverent hands
The books of my numberless dreams;
White woman that passion has worn
As the tide wears the dove-grey sands,
And with heart more old than the horn
That is brimmed from the pale fire of time:
White woman with numberless dreams
I bring you my passionate rhyme.

WILLIAM BUTLER YEATS
1865-1939

Peggy Browne

The dark-haired girl, who holds my thoughts entirely
Yet keeps me from her arms and what I desire,
Will never take my word for she is proud
And none may have his way with Peggy Browne.

Often I dream that I am in the woods
At Westport House. She strays alone, blue-hooded,
Then lifts her flounces, hurries from a shower,
But sunlight stays all day with Peggy Browne.

Her voice is music, every little echo
My pleasure and O her shapely breasts, I know,
Are white as her own milk, when taffeta gown
Is let out, inch by inch, for Peggy Browne.

A lawless dream comes to me in the night-time,
That we are stretching together side by side,
Nothing I want to do can make her frown.
I wake alone, sighing for Peggy Browne.

TURLOUGH O'CAROLAN
(translated by Austin Clarke)
1670-1738

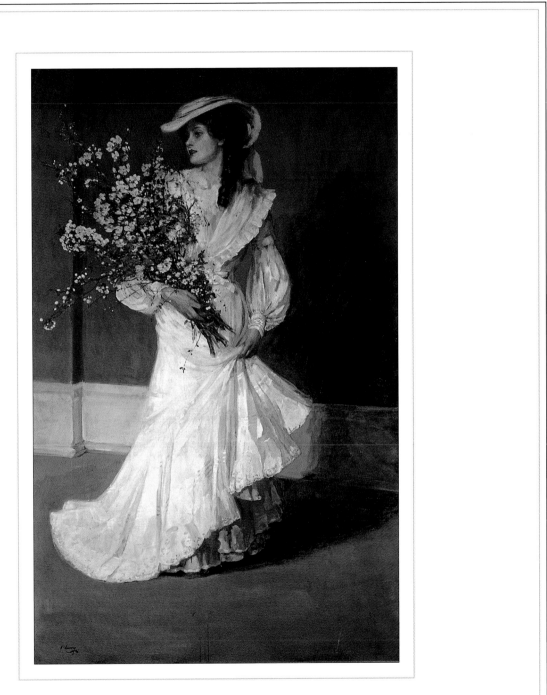

SPRING

Sir John Lavery

1856-1941

T h e
P e n i n s u l a

When you have nothing more to say, just drive
For a day all round the peninsula.
The sky is tall as over a runway,
The land without marks so you will not arrive

But pass through, though always skirting landfall.
At dusk, horizons drink down sea and hill,
The ploughed field swallows the whitewashed gable
And you're in the dark again. Now recall

The glazed foreshore and silhouetted log,
That rock where breakers shredded into rags,
The leggy birds stilted on their own legs,
Islands riding themselves out into the fog

And drive back home, still with nothing to say
Except that now you will uncode all landscapes
By this: things founded clean on their own shapes,
Water and ground in their extremity.

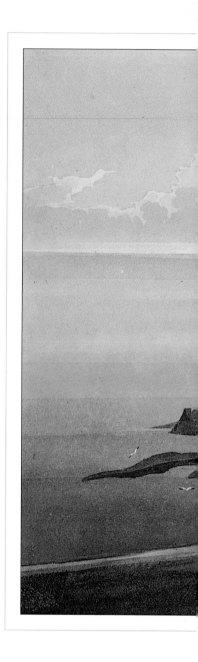

SEAMUS HEANEY
1939-

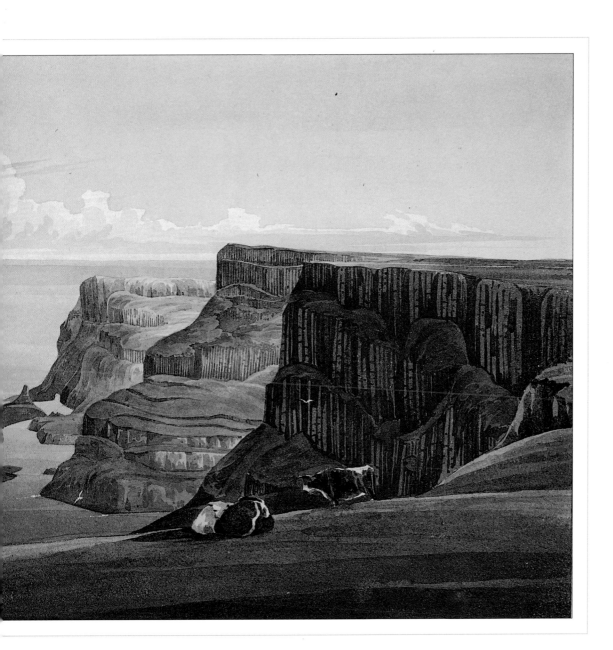

WEST VIEW OF PLEASKIN FROM ABOVE
Andrew Nicholl
1804-1886

Prelude

Still south I went and west and south again,
Through Wicklow from the morning till the night,
And far from cities, and the sites of men,
Lived with the sunshine and the moon's delight.

I knew the stars, the flowers, and the birds,
The grey and wintry sides of many glens,
And did but half remember human words,
In converse with the mountains, moors, and fens.

JOHN MILLINGTON SYNGE
1871-1909

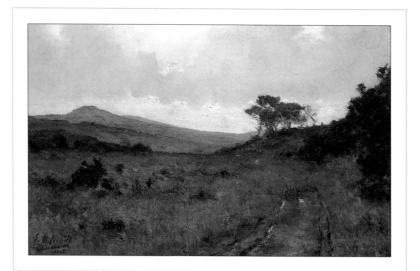

A VIEW OF CASTLETOWNSHEND
Egerton Coghill
1851-1921

Easter 1916

I have met them at close of day
Coming with vivid faces
From counter or desk among grey
Eighteenth-century houses.
I have passed with a nod of the head
Or polite meaningless words,
Or have lingered a while and said
Polite, meaningless words,
And thought before I had done
Of a mocking tale or a gibe
To please a companion
Around the fire at the club,
Being certain that they and I
But lived where motley is worn:
All changed, changed utterly:
A terrible beauty is born.

That woman's days were spent
In ignorant good-will,
Her nights in argument
Until her voice grew shrill.
What voice more sweet than hers
When, young and beautiful,
She rode to harriers?
This man had kept a school
And rode our wingèd horse;
This other his helper and friend
Was coming into his force;
He might have won fame in the end,

So sensitive his nature seemed,
So daring and sweet his thought.
This other man I had dreamed
A drunken, vainglorious lout.
He had done most bitter wrong
To some who are near my heart,
Yet I number him in the song;
He, too, has resigned his part
In the casual comedy;
He, too, has been changed in his turn,
Transformed utterly:
A terrible beauty is born.

Hearts with one purpose alone
Through summer and winter seem
Enchanted to a stone
To trouble the living stream.
The horse that comes from the road,
The rider, the birds that range
From cloud to tumbling cloud,
Minute by minute they change;
A shadow of cloud on the stream
Changes minute by minute;
A horse-hoof slides on the brim,
And a horse plashes within it;
The long-legged moor-hens dive,
And hens to moor-cocks call;
Minute by minute they live:
The stone's in the midst of all.

Too long a sacrifice
Can make a stone of the heart.
O when may it suffice?
That is Heaven's part, our part
To murmur name upon name,
As a mother names her child
When sleep at last has come
On limbs that had run wild.
What is it but nightfall.
No, no, not night but death;
Was it needless death after all?
For England may keep faith
For all that is done and said.
We know their dream; enough
To know they dreamed and are dead;
And what if excess of love
Bewildered them till they died?
I write it out in verse –
MacDonagh and MacBride
And Connolly and Pearse
Now and in time to be,
Wherever green is worn,
Are changed, changed utterly:
A terrible beauty is born.

September 25, 1916

WILLIAM BUTLER YEATS
1865-1939

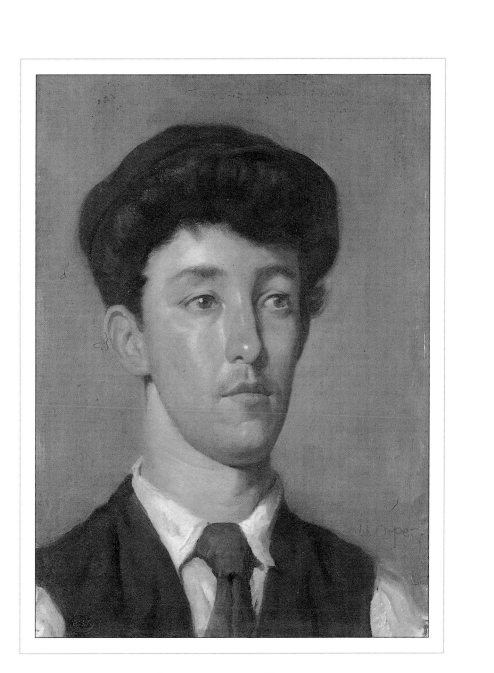

PORTRAIT OF A YOUTH
Sir William Orpen
1878-1931

Drinking Song

Here's to the maiden of bashful fifteen,
 Here's to the widow of fifty;
Here's to the flaunting extravagant quean,
 And here's to the housewife that's thrifty:
 Chorus. Let the toast pass,
 Drink to the lass,
I'll warrant she'll prove an excuse for the glass.

Here's to the charmer, whose dimples we prize,
 And now to the maid who has none, sir,
Here's to the girl with a pair of blue eyes,
 And here's to the nymph with but one, sir.
 Let the toast pass, etc.

Here's to the maid with a bosom of snow,
 And to her that's as brown as a berry;
Here's to the wife with a face full of woe,
 And now to the girl that is merry:
 Let the toast pass, etc.

For let 'em be clumsy, or let 'em be slim,
 Young or ancient, I care not a feather;
So fill a pint bumper quite up to the brim,
 And let us e'en toast them together:
 Let the toast pass, etc.

from The School for Scandal
RICHARD BRINSLEY SHERIDAN
1751-1816

CHERRY RIPE

Jessie Douglas

1893-1928 (active)

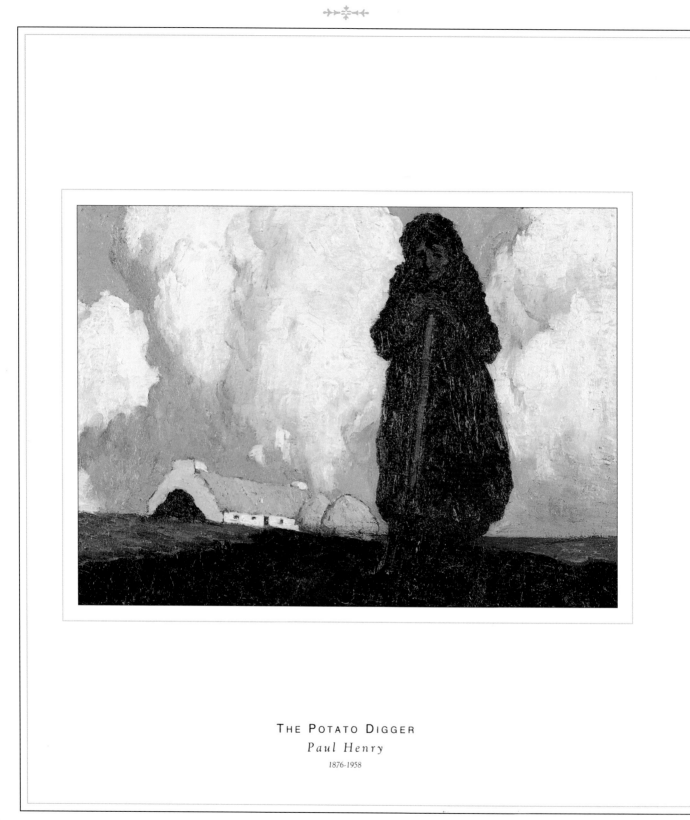

THE POTATO DIGGER
Paul Henry
1876-1958

Any Woman

I am the pillars of the house;
 The keystone of the arch am I.
Take me away, and roof and wall
 Would fall to ruin utterly.

I am the fire upon the hearth,
 I am the light of the good sun,
I am the heat that warms the earth,
 Which else were colder than a stone.

At me the children warm their hands;
 I am their light of love alive.
Without me cold the hearthstone stands,
 Nor could the precious children thrive.

I am the twist that holds together
 The children in its sacred ring,
Their knot of love, from whose close tether
 No lost child goes a-wandering.

I am the house from floor to roof,
 I deck the walls, the board I spread;
I spin the curtains, warp and woof,
 And shake the down to be their bed.

I am their wall against all danger,
 Their door against the wind and snow,
Thou Whom a woman laid in a manger,
 Take me not till the children grow!

KATHARINE TYNAN
1861-1931

The Blackbird

One morning in the month of June
I was coming out of this door
And found myself in a garden,
A sanctuary of light and air
Transplanted from the Hesperides,
No sound of machinery anywhere,
When from a bramble bush a hidden
Blackbird suddenly gave tongue,
Its diffident, resilient song
Breaking the silence of the seas.

DEREK MAHON
1941–

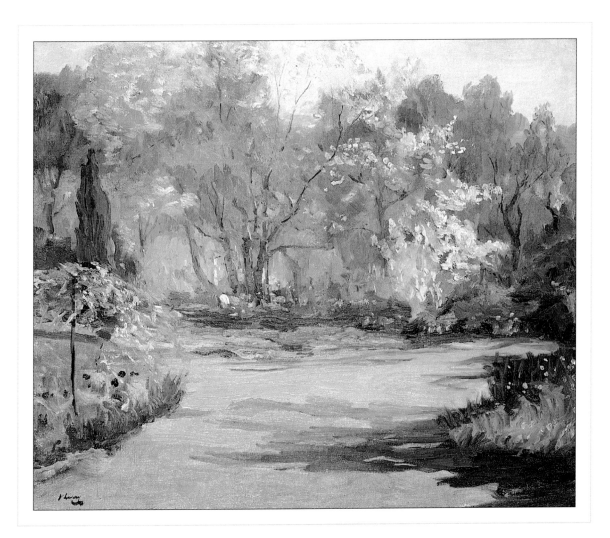

SPRING, THE GARDEN, VILLA SYLVIA

Sir John Lavery

1856-1941

The Lamentation of the Old Pensioner

I had a chair at every hearth,
When no one turned to see,
With 'Look at that old fellow there,
And who may he be?'
And therefore do I wander now,
And the fret lies on me.

The road-side trees keep murmuring
Ah, wherefore murmur ye,
As in the old days long gone by,
Green oak and poplar tree?
The well-known faces are all gone
And the fret lies on me.

WILLIAM BUTLER YEATS
1865-1939

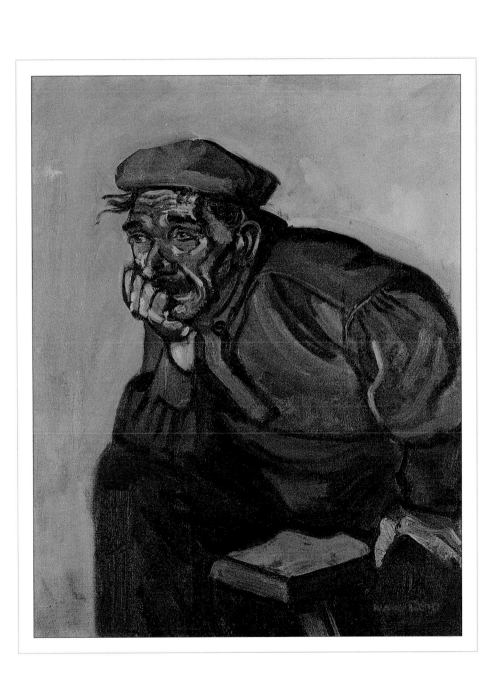

THE LILTER

Nano Reid

1910-1981

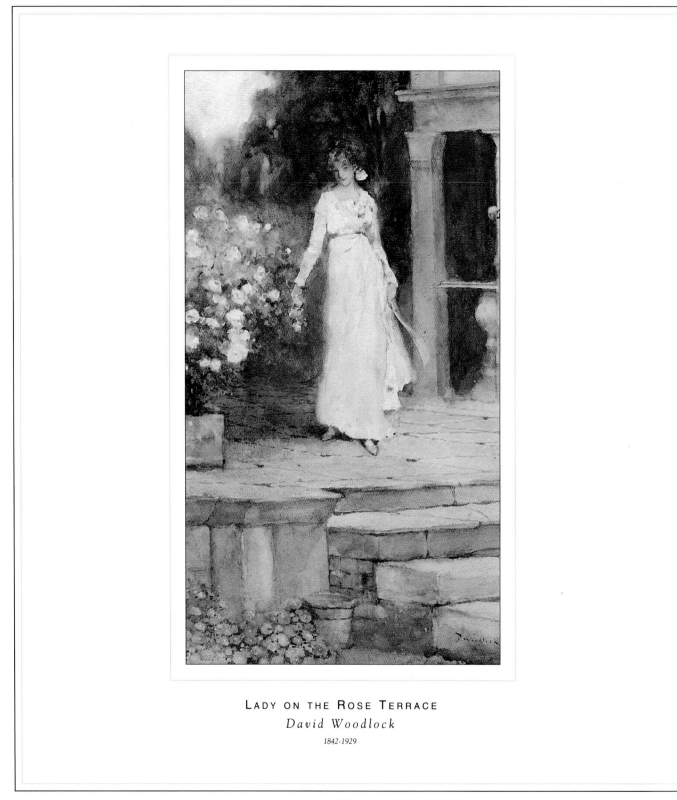

LADY ON THE ROSE TERRACE

David Woodlock

1842-1929

SUMMER TIME
Sir William Orpen
1878-1931

Acknowledgements

Grateful acknowledgement is made to the following for permission to reproduce the poems and paintings in this book. All possible care has been made to trace ownership of selections and to make full acknowledgement. If any errors or omissions have occurred, they will be corrected in subsequent editions, provided that notification is sent to the publisher.

POETRY

SARAH BERKELEY: *The Mass is Over*. Reprinted by permission of the author.

SEAMUS DEANE: *Breaking Wood*. Reprinted by permission of the author and The Gallery Press, Loughcrew, Oldcastle, Co. Meath, Ireland, from *Selected Poems*, 1988.

SEAMUS HEANEY: *Blackberry-Picking* and *The Peninsula*. Copyright © 1966, 1969, 1972, 1975, 1980 by Seamus Heaney. Reprinted by permission of the author and Faber and Faber Ltd., London, and Farrar, Straus and Giroux, Inc., New York, from *Death of a Naturalist* by Seamus Heaney.

JOHN HEWITT: *O Country People* and *The Glens*. Reprinted by permission of The Blackstaff Press, Belfast.

PATRICK KAVANAGH: *Peace, Pegasus* and *Pursuit of an Ideal*. Reprinted by permission of the trustees of the Estate of Patrick Kavanagh, c/o Peter Fallon, Literary Agent, Loughcrew, Oldcastle, Co. Meath, Ireland.

WINIFRED M. LETTS: *Prayer for a Child*. Reprinted by permission of John Murray Ltd, London.

LOUIS MACNEICE: *The Sea* and *Train to Dublin*. Reprinted by permission of Faber and Faber Ltd, London from *The Collected Poems of Louis MacNeice*.

DEREK MAHON: *A Refusal to Mourn* © Derek Mahon 1979, *Everything Is Going To Be All Right* © Derek Mahon 1979, *Rock Music* © Derek Mahon 1982, *The Blackbird* © Derek Mahon 1979 and *Two Songs* © Derek Mahon 1979. Reprinted from *Derek Mahon: Selected Poems* (Viking/Gallery 1991); originally published in *Poems 1962-1978* (OUP 1979) and *The Hunt by Night* (OUP 1982); by permission of the author and Oxford University Press.

JOHN MONTAGUE: *Like Dolmens Round My Childhood, the Old People, The Cage, The Trout* and *Windharp*. Reprinted by permission of the author and The Gallery Press from *New Selected Poems*, 1989.

TURLOUGH O'CAROLAN: *Mabel Kelly* and *Peggy Browne*. Translations by Austin Clarke reprinted by permission of R. Dardis Clarke, 21 Pleasants Street, Dublin 8.

SEAN O'MEARA: *The Lady of the Restaurant*. Reprinted by permission of the author.

FRANK ORMSBY: *A Day in August*. Reprinted by permission of the author and The Gallery Press, Loughcrew, Oldcastle, Co. Meath, from *A Store of Candles*, 1977.

CATHERINE TWOMEY: *Cliona*. Reprinted by permission of the author.

WILLIAM BUTLER YEATS: *Easter 1916*. Reprinted with permission of Macmillan Publishing Company from *The Poems of W.B. Yeats: A New Edition*, edited by Richard J. Finneran. Copyright 1924 by Macmillan Publishing Company, renewed in 1952 by Bertha Georgie Yeats.

PAINTINGS

ART RESOURCE, New York, for pp. 119 and the Tate Gallery, London, for p. 87 and the Trustees of the Victoria & Albert Museum, London, for p. 116.

THE BRIDGEMAN ART LIBRARY, London, for pp. 19, 36, 38-9, 46, 49, 61, 65, 84, 88, 105, 109, 125 and Mrs L. de Buitléar for pp. 28-9; Mr R. McKelvey for p. 103.

CHRISTIES IMAGES, London, for pp. 11, 45, 71, and Ms A. Yeats for permission to print pp. 67, 93.

CRAWFORD MUNICIPAL ART GALLERY, Cork, and Mrs L. de Buitléar for permission to print p. 98.

FINE-LINES FINE ART, Shipston-on-Stour, Warwickshire, for pp. 40, 134.

MR R. GILLESPIE for permission to print p. 115.

THE GORRY GALLERY, Dublin, 20-1, and Mr R. McKelvey for permission to print pp. 62-3.

HUGH LANE MUNICIPAL GALLERY OF MODERN ART, Dublin, and Mr M. Purser for permission to print p. 83.

NATIONAL GALLERY OF IRELAND, Dublin, for pp. 15, 27, 51, 55, 57, 78, 122 and Ms A. Yeats for permission to print p. 35.

SOTHEBYS TRANSPARENCY LIBRARY, London, for pp. 8, 24, 31.

ULSTER MUSEUM, Belfast, for pp. 5, 23, 43, 72, 77, 80-1, 94-5, 97, 106-7, 113, 120-1, 127, 128 131, 141; and Mrs M. Campbell for p. 110; Mrs M. Stoupe for p. 12; Mrs S. McKee for pp. 7, 16 and 58; Mr W. K. Toogood for p. 32; Mr A. O Brien for pp. 52-3; Ms A. Yeats for p. 75; Mrs L. de Buitléar for p. 91; Mr T. Reid for p. 133.

THE BOARD OF TRUSTEES OF THE VICTORIA & ALBERT MUSEUM, London, for p. 68.

The editor thanks all who assisted with the compilation of this book, and in particular Peter Fallon, Térèse Gorry, Joanna Ling, Douglas Marshall, Pat McLean, Joseph McMinn, Poetry Ireland, Deirdre Rennison Kunz and Patrick Taylor, who were invaluable.

Index of artists and paintings

Mabel Kelly

Lucky the husband
Who puts his hand beneath her head.
They kiss without scandal
Happiest two near feather-bed.
He sees the tumble of brown hair
Unplait, the breasts, pointed and bare
When nightdress shows
From dimple to toe-nail,
All Mabel glowing in it, here, there, everywhere.

Music might listen
To her least whisper,
Learn every note, for all are true.
While she is speaking,
Her voice goes sweetly
To charm the herons in their musing.
Her eyes are modest, blue, their darkness
Small rooms of thought, but when they sparkle
Upon a feast-day,
Glasses are meeting,
Each raised to Mabel Kelly, our toast and darling.

Gone now are many Irish ladies
Who kissed and fondled, their very pet-names
Forgotten, their tibia degraded.
She takes their sky. Her smile is famed.
Her praise is scored by quill and pencil.
 Harp and spinet
 Are in her debt
And when she plays or sings, melody is content.

 No man who sees her
 Will feel uneasy.
He goes his way, head high, however tired.
 Lamp loses light
 When placed beside her.
She is the pearl and being of all Ireland
Foot, eye, mouth, breast, thigh and instep, all that we desire.
Tresses that pass small curls as if to touch the ground;
 So many prizes
 Are not divided.
Her beauty is her own and she is not proud.

TURLOUGH O'CAROLAN
(*translated by Austin Clarke*)
1670-1738

Index of first lines

Index of poets and poems